From Art to Politics

MURRAY EDELMAN

From Art to Politics

HOW ARTISTIC CREATIONS SHAPE
POLITICAL CONCEPTIONS

THE UNIVERSITY OF CHICAGO PRESS

CHICAGO AND LONDON

MURRAY EDELMAN is emeritus professor of political science at the University of
Wisconsin–Madison. His previous books include *Constructing the Political
Spectacle* (also published by the University of Chicago Press) and
The Symbolic Uses of Politics.

THE UNIVERSITY OF CHICAGO PRESS, CHICAGO 60637
THE UNIVERSITY OF CHICAGO PRESS, LTD., LONDON

© 1995 by The University of Chicago
All rights reserved. Published 1995
Printed in the United States of America

03 02 01 00 99 98 97 96 95 1 2 3 4 5

ISBN: 0-226-18400-5 (cloth)

Library of Congress Cataloging-in-Publication Data

Edelman, Murray J. (Murray Jacob), 1919–
 From art to politics : how artistic creations shape political conceptions /
Murray Edelman.
 p. cm.
 Includes index.
 1. Politics in art. 2. Art. I. Title.
N8236.P5E3 1995
701'.03—dc20 94-18266
 CIP

TO MY FORMER STUDENTS

CONTENTS

ILLUSTRATIONS

ACKNOWLEDGMENTS

This volume notes several times that a work of art is always a social production, never an individual enterprise, and the same is certainly true of a book. The paintings, novels, films, and other art works that have impressed and influenced me over many years are the primary creators of this book, and the many theorists and historians cited in the notes who have interpreted those works were also vital to its conception.

Friends and trusted scholars are necessary for encouragement, advice, and criticism, especially so for an undertaking that teeters on the edge of my own field of political science; some readers may take the view that it falls over that edge, and that will not disturb me.

The people I wish to thank here have made different kinds of contributions, all important and all deeply appreciated. Marion Smiley has encouraged me through the entire period in which I was working on the book and has given me informed and cogent criticisms of several of the chapters. Judith Strasser and Bernard Yack read a draft of the entire manuscript and helped unify its various facets. Lance Bennett, Dvora Yanow, and Tracy Wahl discussed the ideas with me from time to time and prompted me to revise and improve them. Rozann Rothman has been a source of encouragement and stimulation for many years. Richard Merelman offered useful comments on the general argument and on a number of details. Cathy May has been a sagacious sounding board. Laurel Munger forced me to think through and defend more adequately some theses of which she disapproved. John Tryneski, my editor at the University of Chicago Press, has helped me improve the final manuscript in important respects. My wife, Bacia Edelman, has encouraged this work, read the draft, and helpfully discussed a number of its themes with me.

I am especially grateful to two anonymous readers for the University of Chicago Press, both of whom offered informed and cogent criticisms of a number of the issues that the book addresses while strongly commending the result and so making me feel justified in having undertaken what seemed a somewhat risky enterprise. Their work is all the more valuable because I suspect that one of them is a political scientist and the other an authority in the field of comparative literature.

Chapter 5 draws from and expands upon an essay that was published in the *Journal of Architectural Education* 32 (November 1978): 2–7.

Chapter 7 draws from and expands upon an essay that was published in *Political Communication* 10 (July–September 1993): 231–42.

Finally, I want to thank Laura Gerke and Kathy Kruger for their patient and competent secretarial services.

The Cardinal Political Role of Art

Political beliefs and actions spring from assumptions, biases, and news reports. In this critical sense politics is a drama taking place in an assumed and reported world that evokes threats and hopes, a world people do not directly observe or touch.[1] It is a place composed of the images and models into which people translate the reported news, for that translation is always necessary. A report that American missiles were launched against Baghdad to punish the Iraqi dictator takes its meaning for each person from his or her repertoire of images about historical and fictional military actions, foreign tyrants, Arabs, and perhaps the devastation war brings to civilians. A report that welfare benefits are being increased, or reduced, takes its meaning from inventories of images, scenarios, and narratives about the poor as victims or as cheaters and malingerers; about the consequences of welfare benefits for tax rates; and about poverty as inevitable or as a remediable social scourge.

The models, scenarios, narratives, and images into which audiences for political news translate that news are social capital, not individual inventions. They come from works of art in all genres: novels, paintings, stories, films, dramas, television sitcoms, striking rumors, even memorable jokes. For each type of news report there is likely to be a small set of striking images that are influential with large numbers of people, both spectators of the political scene and policymakers themselves.

Because of the inclination to assume that seeing is an objective process, there is serious underestimation of the extent to which

1. Cf. Murray Edelman, *The Symbolic Uses of Politics* (Urbana: University of Illinois Press, 1964), pp. 5ff.

seeing is constructed and so reflects models that art forms provide. It is true enough that seeing usually is believing, but the beliefs need not be valid or commonly shared. If twelve members of a Simi Valley jury could see a videotape of the merciless beating of Rodney King in 1992 and conclude unanimously that King, not the police, was "in control of the situation from start to finish," then the stories the defense lawyers told them must obviously have led them to see precisely the opposite of what most viewers of the videotape saw. The defense, in turn, benefited from hundreds of novels and movies that depict the police as protectors of social order against the violence of criminals. It relied as well upon oral and written stories portraying blacks as violent and criminal. Narratives and images govern seeing and believing, and they do so all the more effectively when the role these art forms play is subliminal, as is usually the case, rather than visible and evident.

Though only a fraction of the population may experience particular works of art and literature directly, the influence of these works is multiplied, extended, and reinforced in other ways: through variations and references in popular art and discourse; through "two-stage flows," in which opinion leaders disseminate their messages and meanings in books, lectures, newspapers, and other media; through networks of people who exchange ideas and information with each other; and through paraphrases that reach diverse audiences.

In a crucial sense, then, art is the fountainhead from which political discourse, beliefs about politics, and consequent actions ultimately spring. There is, of course, no simple causal connection here, because works of art are themselves part of the social milieu from which political movements also emerge; but there *is* a complex causal connection. Contrary to the usual assumption—which sees art as ancillary to the social scene, divorced from it, or, at best, reflective of it—art should be recognized as a major and integral part of the transaction that engenders political behavior. The conduct, virtues, and vices associated with politics come directly from art, then, and only indirectly from immediate experiences. Works of art generate the ideas about leadership, bravery,

cowardice, altruism, dangers, authority, and fantasies about the future that people typically assume to be reflections of their own observations and reasoning.

But, as already noted, political events are typically reported or assumed. Both reporters' and spectators' observations take their meaning from memorable images that derive directly or indirectly from art rather than from objective observation, which cannot take place in any case and is itself a myth. Philosophers and historians define art in many different ways;[2] but for this study, its crucial feature is that it supplies images that construct the worlds in which we act. Precisely because those images *are* constructions, the notion that beliefs and observations are objective, and hence that inferences from them are essentially rational, needs to be profoundly qualified if not rejected outright. Even when great care is taken to maximize accurate observation, the resonances of what is seen and how it is interpreted carry a decisive spillover effect from relevant works of art.

Chapters 2 through 5 explore the diverse forms of influence that art exerts on political beliefs and actions. Chapters 6, 7, and 8 examine some ways in which art and politics are intertwined that are more rarely noticed but are very likely even more basic. Art forms are incorporated into governmental processes themselves, influencing authority and subordination. Art creates contestable categorizations of public issues that reflect particular conceptions and particular ways of experiencing contemporary times. And art shapes, displaces, and sometimes supersedes cherished influences upon public policy like voting and lobbying.

This book should therefore complement the impressive analyses by art historians, notably in the twentieth century, of the influence of social and political conditions upon art,[3] because it focuses

2. For an enlightening review of the range of approaches to definitions of art and aesthetic experiences, see Janet Wolff, *Aesthetics and the Sociology of Art,* 2d ed. (Ann Arbor: University of Michigan Press, 1993).

3. Among the more notable writings of art historians in this vein are: Herbert Read, *Art and Society* (New York: Schocken Books, 1966); Frederick Antal, *Florentine Painting and Its Social Background* (Boston: Boston Book and Art

on the converse form of influence even while it calls attention to a political phenomenon too rarely examined in political studies.

The images and models that art supplies to political discourse are usually catalysts toward confidence that the political scene is understandable, as opposed to the disorder, murkiness, and contradictions that characterize much of everyday experience; this effect enhances their influence still further. A great deal of art portrays the disorder and contradictions in people's lives in ways that make them comprehensible. Some art, on the other hand, clarifies through simplistic portrayals: former political figures and current ones become effective, heroic, inept, or disastrous as they are compared with clear-cut political figures fitting these descriptions who are drawn from romantic fiction or from polemical historical writings. A past war, like World War II, may become a legendary triumph while its victims, its inept strategies, and its disturbing side effects fade from attention. Such clarity is inevitably misleading in key respects, sometimes minor and often major. A great deal of art, by contrast, contributes to discernment by exploring the nature of the ambiguities that pervade everyday life.[4]

The choices people make from the menu of models that works of art offer them are bound to be driven by ideology. Art and ideology ensure that there is no immaculate perception. By the same token, there can be no politics without art and ideology.

Shop, 1965); Frederick Antal, *Classicism and Romanticism* (New York: Basic Books, 1966); Arnold Hauser, *The Social History of Art* (New York: Vintage, 1951), 4 vols.; Janet Wolff, *The Social Production of Art* (New York: New York University Press, 1981); Arthur Danto, *Encounters and Reflections* (New York: Noonday, 1991); T. J. Clark, *The Painting of Modern Life: Paris in the Art of Manet and His Followers* (New York: Knopf, 1985); Ron Robbin, *Enclave of America: The Rhetoric of American Political Architecture Abroad, 1900–1965* (Princeton: Princeton University Press, 1993); Mikhail Bakhtin, *Rabelais and His World* (Bloomington: Indiana University Press, 1992); Antonio Gramsci, *Prison Notebooks* (Boulder: Colorado University Press, 1992); György Lukács, *History and Class Consciousness* (Cambridge: MIT Press, 1971); Karl Marx and Friedrich Engels, *Literature and Art* (New York, 1947).

4. For a more extensive consideration of the ambiguities to which art calls attention, see pp. 61–65.

Classification is therefore central to political conception and political maneuver, for each category calls up particular images and models.

Together, art, the mind, and the situations in which they are applied construct and transform beliefs about the social world, defining problems and solutions, hopes and fears, the past, the present, and the future. But for the most part they do so in masked fashion, leaving the impression that these beliefs rest upon observation. That misperception creates both political confusion and an intellectual challenge. The political analyst must try to tease out what is going on—a daunting challenge, but also an exhilarating and sometimes surprising one.

MISUNDERSTANDINGS ABOUT THE POLITICAL ROLE OF ART AND LITERATURE

In early childhood people begin to acquire ideas about the social world. That world seems to be stable and continuous, waiting for us to enter it and act within it. It appears so because that is the way cues in our language and stories and in the literature and art to which we are exposed depict it, and because parents, schools, and other authorities also portray social institutions in that fashion—for example, teaching children to conform to the laws, customs, and expectations that can hurt or help them as they grow.

It is not easy to recognize that that conception, as well as changes in it when they occur, is not a description of a self-evident reality, but rather a construction that can be questioned and altered when the cultural means for doing so appear. In fact, these constructions are often altered in response to changes in environment or future prospects—sometimes for a particular person or group, and sometimes for much of the population alive at a particular time.

Works of art and literature offer conceptions and perceptions that can be adopted or changed to fit needs, fears, interests, or aspirations. There is no neat correlation between the conspicuous art of a period and the political ideas and discourse it stimulates. But the body of extant art does provide a reservoir of

images, narratives, schemata, and models from which everyone draws.

There can be no conception without some kind of shared objectification to symbolize it in the form of images or discourse. The latter become the means for taking other people's roles, which is the necessary foundation for thought.[5] Art is therefore an essential and fundamental element in the shaping of political ideas and political action. Ideas of heroes and villains, of planning for a more desirable society, of threats to well-being, of forms of action that will or will not achieve the goals we seek, and other paramount political conceptions emerge, as already suggested, from written and oral stories, novels, romances, films, paintings, and other forms of high and popular art. Art provides the cognitive and emotional resonances such political actions carry, and it may play a part in providing details as well, though its precise role in that respect doubtless varies with issues and circumstances.

Exposure and reaction to particular art forms is certainly selective, reflecting their degree of availability to various people as well as the intentions and biases of individuals and groups. But even when art reinforces preexisting prejudices, its contribution of images and other symbols is vital. Without that contribution, alternative perceptions become more potent and displace the prejudiced ones.

Well-known works of art often construct contradictory messages. The ideology of the public, or segments of it, along with the aptitude of spokespersons (lawyers, editors, public officials, teachers, and others) for focusing on a particular kind of narrative, shape audience response. Wars become heroic but may also become futile or unnecessary in light of the narratives that depict them.

More generally, works of art and literature can create perspectives regarding objects and scenes in everyday life and in history that are not otherwise apparent or not otherwise prominent. George Eliot and Thomas Hardy created a benign, romanticized,

5. For theoretical development of this key point, see George Herbert Mead, *Mind, Self, and Society* (Chicago: University of Chicago Press, 1934).

sentimental view of low-status residents of rural England that continues to influence public opinion. Constable in England and Millet in France also helped construct a romantic view of rural life, as did many Chinese scroll paintings. *Othello* has shaped judgments of male erotic jealousy, and perhaps of racial differences as well, for all time. Picasso's *Guernica* and Remarque's novel *All Quiet on the Western Front* provide images of the horrors of war that are always available for use, while at the same time countless heroic paintings and written depictions of battle scenes provide useful conceptions for advocates of involvement in particular wars.

The catalog of conceptions and perceptions stemming from works of art and forming political ideas and actions can be extended indefinitely. It is these, not the appeals, fears, or enthusiasms of the moment, that exert the fundamental influence on political maneuvering and its outcomes, for they shape the meanings of everyday developments.

The plain lesson of these observations is that works of art do not represent "reality," "the real world," or "everyday life," even if those terms are taken to carry a specific or meaningful reference. Rather, art *creates* realities and worlds. People perceive and conceive in the light of narratives, pictures, and images. That is why art is central to politics, just as it is central to social relationships and to beliefs about nature. There cannot be any representation that reproduces another entity, scene, or conception, but only constructions that may purport to reproduce reality while simplifying, elaborating, accenting, or otherwise constructing actualities and fantasies. Because they create something different from conventional perceptions, works of art are the medium through which new meanings emerge. For the same reason, this account, like all others, is also a construction, shaped to accent, elaborate, and simplify in line with its purpose.

The political meanings of works of art, then, are never given, but always "taken," by political leaders and followers. Every event and action is a complex and ambiguous phenomenon. Its division into fundamental and marginal components, its purport, and the

boundaries that separate it from other events depend on subjective judgments. All possibilities cannot be grasped, so we search for a model that resolves ambiguities and reduces possibilities to one or a few. Art supplies the menu of models. From one perspective, that is its essential function.

But that function embraces more than the elimination of many conceptual possibilities. Possibly the key attribute that makes some artists great is their talent for creating works that stimulate the imagination, revealing new possibilities and unperceived levels of "reality," perhaps as what twentieth-century linguists call "deep structures." They similarly create fantasies that influence thought, everyday perception, and behavior. Consider, for example, the uprisings in Los Angeles and other cities in 1992 following the acquittal of the policemen who had beaten Rodney King. Mass violence in response to an injustice that threatens the members of a group is a model of action that has appeared countless times in novels, poetry, and historical accounts, from the Spartacus uprising in ancient Rome to the ghetto uprisings in America in the 1960s. Rioting is neither spontaneous nor automatic, but a response to a dramatic script that has often provided one scenario out of many that might be followed in such a situation: personal despair; revenge on the jurors and police; political action to change the criminal justice system radically; group retaliation for past wrongs, real or imagined; public oratory to win political support; and still others.

Among participants in the Los Angeles disturbances there was as well a fatalistic sense that the cycle of violence, injustice, uprising, and further violence is inevitable and is bound to continue indefinitely and probably grow more intense. That model of bloodshed, revenge, and fated violence that is periodically reignited through the generations and cannot be stopped goes back at least as far as ancient Greek tragedy and the *Oresteia*. It has become a prominent theme in Western thought, even for those who have never witnessed or read the works of Aeschylus, and it appears frequently in contemporary plays, novels, and discourse. It

is closely related to the theme of character flaws that yield tragedy for all, though evaluations of the motives and the flaws of Orestes, Electra, and Clytemnestra vary for different observers. Such art helps explain the repeated effort in twentieth-century America to trace rioting to individual defects and inadequacies on the part of rioters, public officials, and juries rather than to social injustices and inequalities. Works of art and literature construct models of action, which are then attributed to personal or collective planning or plotting, to psychopathology, or to emotion.

Michelangelo's depictions in the Sistine Chapel of the Last Judgment, of God, and of the biblical accounts, portrayals of these themes by other artists, and the scriptural narratives themselves offer another striking example of the artistic stimulation of fantasy that continues to influence and to justify legal and moral codes and behavior, including the rationalization of officially sanctioned punishments, tortures, and killing.

Works of art, then, construct and periodically reconstruct perceptions and beliefs that underlie the political actions in the news, even when their role is concealed, as is usually the case. They create diverse levels of reality and multiple realities. Sometimes they even call public attention to the diversity and multiplicity characteristic of beliefs about reality, as surrealist paintings do and as James Joyce's novel *Ulysses* does. At other times they construct beliefs in one true reality, as do both positivist scientific writings and fundamentalist religious tracts. It is art that evokes idealizations, threats, and beliefs about the proper places of masses, leaders, obedience, heroism, evil, and virtue.

From one perspective the art simply serves as a floating signifier into which political groups read whatever serves their interests and ideologies. An awesome image of God can signal compassion, vengeance, or terror. Dadaist paintings can represent the repudiation of capitalism and bourgeois culture or the absurdity of twentieth-century human existence or nothing at all. It nonetheless remains true that works of art are the essential catalysts of support for a course of political action, and sometimes for several

(perhaps contradictory) courses. They provide the images that enable many individuals to become part of a politically conscious group and that shape and justify policy initiatives.

In the light of specific conditions a particular reading of the meaning of art is likely to spread widely, especially among opinion leaders. The Great Depression of the thirties brought compassion for the poor and the unemployed, deep suspicion and resentment of the inequities of capitalism, fear of fascism, and support for social programs. These meanings of the contemporary news were not the only possible ones, but were rather a consequence of the messages conveyed by prominent novelists, playwrights, and painters including Lewis, Faulkner, Odets, Picasso, Malraux, Steinbeck, the cartoonists of *The New Masses*, and some of the painters supported by the WPA's Federal Arts Project. Depression conditions also brought into prominence some art works made before the twentieth century that could be read as conveying the same meanings, including, among others, those of Balzac, Zola, and Dickens. Many, perhaps all, of these paintings, plays, and novels can be interpreted in different, even ideologically opposite, ways as well; in altered economic and social circumstances they have been. But they remain a necessary foundation for shared political sentiment.

Nor need they convey specific substantive meanings. Sometimes, like Picasso's *Guernica* or Odets's *Waiting for Lefty*, they do that, eloquently. More often their message is a more general and therefore an even more influential one: a view of human action as fundamentally rational or absurd, as offering hope or only despair, as energized by the conscious efforts of individual leaders or enemies or by social conditions or uncontrollable forces (God, modes of production, fate, national destiny, inequalities) that create the leaders and the enemies. They may presuppose the view that earthly lives, joys, and sorrows are evanescent and insignificant phases in a more fundamental, perhaps celestial, drama, or that material conditions are decisive and paramount. They may see people as equal or unequal in value and deserts, nature as the paramount resource or as exploitable and peripheral to other con-

cerns. In evoking such intellectual and moral outlooks, works of art become far more influential in politics than polemics can be, because they imbue discourse and action with a crucial meaning regardless of what forms these take or how they are rationalized in a particular political arena.

As already suggested, not all who share the sentiment are acquainted with, or even aware of, the art that played a part in crystallizing their political opinions. Like all communication, these conceptions spread through discourse, paraphrases, imitations, and emulation, and through attacks on them as well. Their key political consequence is to focus attention, fundamental assumptions, and ideology.

Works of Art as Shapers of Political Beliefs

The construction of worlds with invented categories and invented cause-effect relationships is strongly influenced in these ways. Good and bad art provides the images and stereotypes into which we translate the news: the competent, exceptional leader; evil or good groups of people; the efficient, tough general; the welfare cheat; the soldier or worker who wants and needs leadership; the designing woman; the corrupt politician; and so on. News reporters, editors, interest groups, and supporters of political causes help induce the public to fit current situations into these models, in which each category or image implies or presupposes a story that bolsters its political impact. Rival political groups propose conflicting models.

The image of the tough general, for example, evokes a narrative about enemies who will be overcome if military means are made available, but who will triumph if there is reliance on irresolute leaders. Works of art similarly provide plot patterns into which we translate news reports. Among the more common are the triumph of virtue, the threats posed by unreason, and the act of God.

Art in diverse media accordingly shapes perception of the everyday world through novel combinations of rubrics and classifications, though this novelty typically escapes conscious awareness.

Art can also *emancipate* the mind from stereotypes, prejudices, and narrow horizons. It repeatedly generates new and useful ways of seeing the world around us. As Arnheim put it, "on occasion an artist comes upon an image that embodies some basic subject with a spellbinding validity. The same story, the same composition, or the same posture lives on for centuries as an indelible contribution to the way man visualizes his world."[6] Nelson Goodman makes a similar point: "The marking off of new elements or classes, or of familiar ones by labels of new kinds or by new combinations of old labels, may provide new insight. . . . if it [a picture] calls for and yet resists assignment to a usual kind of picture, it may bring out neglected likenesses and differences, . . . and in some measure remake our world."[7]

When Pablo Picasso was told that his portrait of Gertrude Stein did not look like her, he is said to have responded, "No matter; it will." The implication, of course, is that Stein would come to be seen in the light of Picasso's portrait. To quote Goodman again, "Nature is a product of art and discourse."

Käthe Kollwitz's portraits of working women, like the *Poster for the German Home Workers Exhibition* of 1906 (fig. 1), undermine the common political depiction of workers as an abstraction that is less than human: manual workers as lazy or stupid; workers in general as a threat to the respectable classes. In her drawings and paintings we see workers as fellow human beings, and we see the pain of poverty and of lives lived under miserable circumstances. Kollwitz's art offers poignant reminders that popular political images too often neglect the experiences and feelings of the disadvantaged.

The revealing but hardly surprising conclusion follows that both popular and academic discourse about government too often

6. Rudolf Arnheim, *Art and Visual Perception: A Psychology of the Creative Mind* (Berkeley: University of California Press, 1974), p. 144.

7. Nelson Goodman, *Languages of Art* (Indianapolis and New York: Bobbs-Merrill, 1968), p. 33.

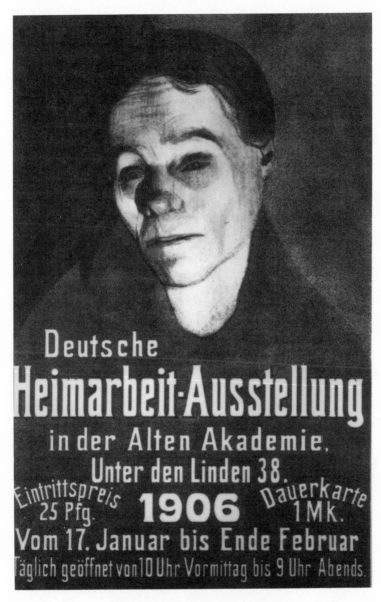

FIGURE 1. Käthe Kollwitz, *Poster for the German Home Workers Exhibition* (1906).

focuses upon alleged sources of influence that either make little difference or are by-products of more significant institutions, while the political influences that do fundamentally affect well-being are sometimes not recognized as political in character, and in other instances are not seen as influences upon government at all.

Art: Political Messages and Illusions

PERCEPTION, ILLUSION, AND LATENT MEANINGS

Gombrich paraphrases an old Chinese treatise: "Everyone is acquainted with dogs and horses since they are seen daily. To reproduce their likeness is very difficult. On the other hand, since demons and spiritual beings have no definite form and since no one has ever seen them they are easy to execute."[1]

The lesson this observation conveys about political perception is clear enough, though it is too seldom remembered as we assess the news. Accurate and realistic accounts are difficult; but imagined threats, issues, heroes, and events are easy to contrive. Because such ready inventions always serve the interests of some of the parties to political conflict (as do realistic accounts), they constitute a high proportion of political discourse. With the growth in the last century of elite access to most of the public and the surge as well in knowledge about techniques of persuasion and how to create credible illusions, imagined political phenomena are also potent negotiation weapons.

Categories and images carry latent meanings that can mask their ideological implications and the reasons for their emotional thrust. Up and down, left and right, sacred and profane, civilized and barbarian, and many other dyads are images that translate readily but not always self-consciously into support or opposition to particular people and causes. Discussing one striking example, Arnheim writes: "Day and night become the visual image of the conflict between good and evil. The Bible identifies God, Christ, truth, virtue, and salvation with light, and godlessness, sin and the

1. E. H. Gombrich, *Art and Illusion: A Study in the Psychology of Pictorial Representation* (Princeton: Princeton University Press, 1969), p. 269.

Devil with darkness."[2] He could have illustrated his provocative observation with many other examples, perhaps noting that Shakespeare repeatedly evokes an atmosphere of threat and evil by depicting scenes that take place in storms and usually in darkness.

In political discourse the same rhetorical device is a typical ploy, though only rarely used as poetically as in these examples. Still, it is effective: imagined bourgeois families that serve as a benchmark for deploring the moral or financial behavior of the poor; imagined military heroes who exalt the images of contemporary generals; imagined villains who justify long prison terms for real defendants whose prosaic records would be less impressive without the analogy. It is easy to generate issues, threats, and reassurances precisely because they are not factual accounts.

Seeing is based on expectations more than on observation, enhancing the role of imagination still more. What is expected guides what is noticed, how it is interpreted, and what is ignored. After years of cold or hot war, an antagonist's conciliatory gestures become deception rather than conciliation. The stupid or otherwise regrettable actions of an admired head of state become invisible or clever strategy. Perception springs from prognosis,[3] leaving ample opportunity for the play of imagination, rationalization, or illusion and therefore for resort to these talents to justify or denounce any policy at all. As these illustrations suggest, the associations that particular categories evoke proliferate indefinitely, influencing reactions to issues, images, and terms regardless of whether their creators intended them to do so. In a sense, they create sentiments, moods, and ideologies that play their parts in a range of responses too wide to define.

Illusion is easily generated and accepted when supportive clues, especially ideological ones, strengthen one another, and no contradictory evidence challenges them. In this perspective, cubism

2. Arnheim, *Art and Visual Perception*, p. 324.

3. Cf. Gombrich, *Art and Illusion*, pp. 274–75, 303. The psychological mechanism that accounts for part of this phenomenon is cognitive dissonance. Cf. Leon Festinger, *Conflict, Decision and Dissonance* (Stanford: Stanford University Press, 1964).

can be understood as an effort to show contradictory indications and so "prevent a coherent image of reality from destroying the pattern of the plane."[4] Political discourse, by contrast, typically entails an effort to depict a coherent, uncontradicted narrative or to discourage attention to contradictions, protecting fantasy and inventions from challenge. For most Americans, forty-five years of claims about the aggressive capability and militaristic intentions of the Soviet Union proved central to fears and ideologies although, as hindsight now shows, other clues should have contested those assumptions severely. Decades of long prison sentences for drug possession and abuse have done nothing to curtail these pathologies, yet remain a popular response to the problem. Although we see largely what we think we know exists, what we "know" is often wrong, and especially so in politics.

ART AS CAUTION AGAINST ILLUSION

Yet art can be a corrective. A key aspect of the ideas and associations that art evokes lies in their challenge to common beliefs or in their augmentation of those views, especially when the beliefs are so taken for granted that they are neither expressed nor consciously taken into account. It is therefore necessary to focus as much on the background assumptions of a work of art as on its explicit content in order to understand its social and political import. The baroque and the rococo art of the eighteenth century, for example, derived its meaning from its challenge to the courtly art that had earlier been taken for granted as supreme and proper. And the baroque-rococo tradition in its turn became the background against which the emotionalism and naturalism of Rousseau and Richardson can be understood, and against which the rationalism of Lessing and David also take on their meaning. This change signaled movement from the dominance of an aristocracy to the age of bourgeois hegemony in Europe.[5]

Indeed, the vacillation in art forms that characterized the

4. Arnheim, *Art and Visual Perception,* p. 281.
5. See Hauser, *The Social History of Art,* vol. 3, p. 4.

eighteenth century was intimately related to the competition for political and social dominance in that century among royalty, aristocracy, bourgeoisie, and proletariat. Hauser notes that until the middle of the century the art forms "waver between tradition and freedom, formalism and spontaneity, ornamentalism and expression."[6]

It is not, then, novel depictions, situations, or styles in themselves that make art works or movements worthwhile, but rather how well they clarify, illuminate, or interpret a universal theme. Arnheim writes, "There is more imagination in the way Titian paints a hand than in hundreds of surrealist nightmares depicted in a dull, conventional manner."[7] But he would doubtless agree that paintings by Dali, Tanguy, and De Chirico are important commentaries on such topics as time, space, affinities with others, and existential terrors and emptiness, creating new forms of consciousness with regard to such concerns. In this respect Elizabeth Helsinger makes the insightful point about Constable that "the naturalizing of the human elements—and especially human labor—in the landscape has . . . an ideological function."[8]

Hauser saw nineteenth-century romanticism as the expression of middle-class individualism: a permutation, then, of attitudes like laissez-faire and the liberation of individual energies promised by the industrial revolution.[9] The romantic movement objectified this posture and sanctified it, a service some form of art doubtless had to perform in order to legitimate actions that would otherwise be even more widely questioned as immoral and inappropriate.

The legacy of inherited art reflects diverse sets of postures toward reality. One of the most basic conflicts lies in the contrast between art that demonstrates anguish, disgust, pride, or concern with particular instances of human action and art that constructs a world from outside the cognition and feeling of living human

6. Ibid., p. 14.

7. Arnheim, *Art and Visual Perception*, p. 142.

8. Elizabeth Helsinger, "Constable: The Making of a National Painter," *Critical Inquiry* (Winter 1989), p. 258.

9. Hauser, *The Social History of Art*, vol. 3, pp. 56–57.

beings. The dichotomy corresponds only roughly to that between romantic and expressionist art on the one hand and classic art on the other: *Laocoön* versus the sculptures of Phidias, Goya versus David, romantic poetry versus pastoral poetry. Political correlates of these respective postures are clear enough: utopian writings and demands versus appeals to the suffering or the unjustified governmental benefits of particular groups.

When works of art depict horror and nausea in everyday life— as do Arthur Miller's *Death of a Salesman,* the *Chants de maldoror* of the nineteenth-century French poet Lautréamont, and many other creations—they evoke as well a sensitivity to the deception and horror that often pervade political and social life and help create ghastly social conditions.

By the same token, a breakdown of established categories is likely to mean as well a breakdown of established hierarchies of values, and perhaps the stimulus for the emergence of new realities. It can bring intellectual chaos and a search for new value hierarchies and new forms of order. Dore Ashton has noted that such a breakdown of categories and conventional perceptions of reality was precisely the purpose of the dada movement, and the effect stems as well from some other types of art works. Ashton cites the Antonioni film *The Red Desert* as an example; Sartre's novel *Nausea* is certainly another.[10]

The rejection of coherence and continuity, especially in a considerable body of twentieth-century art, may call attention to, even help evoke, their frequent absence in other realms, perhaps especially politics, in spite of the predictable claims of public officials that their actions are consistent and logical. The remarkable record of the Bush administration, for example, in arming foreign dictators in Panama and Iraq and then launching wars against these recent allies, and its transformation of the dictator Assad in Syria from vicious terrorist to close ally, can be seen as itself a form of dada, breaking down established categories and values.

10. Cf. Dore Ashton, *A Reading of Modern Art* (New York: Harper and Row, 1969), p. 197.

In a less marked way, sixteenth-century mannerism and similar artistic movements at other times have both reflected and encouraged skepticism toward traditional social and political assumptions. Such skeptical developments appear when there is disillusionment about beliefs that have been dominant for some time. The artists who created the mannerist movement lived in an age in which the medieval certainties were fading for many, just as the artists of the early twentieth century lived during the breakdown for many people of the nineteenth-century certainties about rationality and progress. In both periods, art encouraged experimentation with new social behaviors, new theoretical avenues, and diverse forms of political and social action.

Because it can be ahead of general opinion, art becomes controversial at such times, and in some measure becomes symbolic of rebellion and dissent. It may be especially effective at disseminating skepticism when that message is enshrined in a conventional display. Shakespeare illustrates brilliantly the possibility of accepting, even extolling, established hierarchies and elites while undermining them through a penetrating portrayal of social institutions, as he does repeatedly in the history plays, *Coriolanus,* and elsewhere. He employs the same device respecting women, depicting them as fitting into established hierarchies while frequently showing their demeaning dependence on men, as in *Antony and Cleopatra, Othello,* and *Richard III.*

Shakespeare's tragedies, like the classical tragedies of ancient Greece, offer a model of a social world in which there is a great deal of irrationality and defeat of virtue, either through character flaws or through social forces, ignorance of causes and consequences, immorality, and evil. The character flaws and the social forces create and reinforce one another so that the state often becomes a major source of tragedy rather than a protector of the common good. In *Romeo and Juliet,* for example, the intervention of the state through the Prince to punish wrongdoing (Tybalt's murder) produces much greater tragedy rather than a state made whole through justice. The well-intentioned actions of major char-

acters yield defeats and misery. The state as threat or danger is a common theme in the Greek tragedies as well, perhaps most notably in *Antigone* and *Oedipus Rex.* The inherent tension between art and the social setting shows itself repeatedly. It achieves one of its most eloquent statements in *Don Quixote,* where madness is more successful than reason in a crazy social order.

The link of art to the assessment of everyday life hinges, paradoxically, on the distancing of works of art from that life. Art does not provide observation of life but rather the kind of commentary and reflection that spring from a detached perspective. Memory obviously plays an important part in the production of all art, but Gombrich usefully reminds us that so far as painting is concerned, it is "a memory of pictures seen."[11] The artist does not observe everyday events and reproduce them, but rather interprets them through the paradigms that earlier art has established and through the discernment of his or her disciplined eye. The mannerist painters and writers of the sixteenth century were less "realistic" than their High Renaissance predecessors, but they recognized and taught a great deal about how life becomes intriguing: through sensuousness, horror, recognition of vulnerability, melancholy, playfulness, irony, ambiguity, and attention to diverse social and natural situations.[12] Their conceptions both buttressed and reflected concern with the quality of everyday life, willingness to innovate and experiment, and other political impulses. It is a posture that contrasts markedly with a common political emphasis on puritanism, fear of the new, and repression of change. It may be that all art—except the kitsch that political propaganda so often is—presents this posture, though mannerism made it especially apparent. Without the insights that art offers, conventional and superficial assumptions are likely to dominate thought.

11. Gombrich, *Art and Illusion,* p. 314.

12. For a discerning discussion of these qualities of mannerism see Jacques Bosquet, *Mannerism: The Painting and Style of the Late Renaissance* (New York: Braziller, 1964), esp. pp. 215–80.

INTERNAL RELATIONS AND BEAUTY IN ART

The twentieth century has witnessed a major reassessment of the essential elements of art, a development that is certainly related to the advent of pessimistic conclusions in philosophy and science. In contrast to the optimism that was a dominant note in the nineteenth century, these judgments question the possibility of certain knowledge and the likelihood of progress, define the human subject as a peripheral construction rather than the center of the social world, see reason and instrumental intelligence as inherently flawed, and look upon language as a form of action that can contribute to any kind of result rather than as a means to promote rationality. These developments are related as well to the marked disillusionment in public postures toward the state and other social institutions, and have helped to particularize and spread such disillusionment. Partly displacing a literature, an art, and a public discourse that sees government as embodying the possibility of an idealized and harmonious reflection of the commonweal, at least in principle, there is now a widespread inclination to believe that government is inevitably hostile to the interests of majorities and inherently discordant in itself.

A twentieth-century reconceptualization of art is closely linked to these changes and has doubtless helped to shape them, for it has both redefined the boundaries of art and given new meaning to the internal structure of paintings. From the beginning of the century to the present time there has been a strong emphasis on the relations among the objects and spaces depicted in a painting. Objects, including people, become foci of the forces these relations create rather than independent bearers of meaning, a view also reflected in twentieth-century social science. Matisse built and defined this perspective throughout his career, and it subsequently became the dominant feature of a great deal of painting, especially in the sixties and later. Discussing this phenomenon as it applies to the abstract expressionists, Dore Ashton has offered the provocative suggestion that Jackson Pollock and others in a sense included painters as inside the relationships evoked by cre-

ating a painting, because they stood above it as they worked on it on the floor rather than addressing it as a separate object resting vertically on an easel.[13]

Concentration on internal structures and their consequences has brought a corresponding abandonment of the view that beauty is a necessary or defining attribute of art. It has brought a new focus instead on relations among ordinary, found, or "readymade" objects and on the place of commonplace objects in a physical or social setting. The objects and the patterns they present are frequently ugly rather than beautiful. "Performance art" often exhibits similar characteristics.

The phenomenon appears as well in other twentieth-century arts. In music, atonality has become an accepted mode of composition; and popular music such as rock and roll and rap appears to substitute volume, dissonance, and social criticism for harmony and beauty. Twentieth-century literature exhibits a similar tendency, as in Georges Bataille's work and other contemporary French fiction, some of Joyce's later writing, and a considerable body of poetry.

Disharmony and unattractive appearance can be a commentary on, or a criticism of, the disorder and unpleasant ambiance of contemporary society and government. To depict the world as beautiful is to presuppose that its basic institutions can be ideal in principle even if they fall short in practice. But a considerable amount of twentieth-century art implies or proclaims that disharmony and its unpleasant concomitants are innate. In conveying that outlook, these works may also encourage examination of the specific social practices and institutions that are to blame.

Such art forms also signal a hostile stance toward ties to bourgeois society, capitalism, and politics, and against conventional respectability; they seem to want to undermine these institutions,

13. Ashton, *A Reading of Modern Art*. The focus on internal structures as a reflection and commentary on the external world is manifestly a different posture from such a focus as an exclusion of that world in favor of a formalist concentration on the internal relationships of a work of art.

as some artists, notably those in the dada movement, explicitly proclaimed and as the intense right-wing attacks on this art imply.

Such tendencies have their obvious parallels and derivatives in twentieth-century political discourse: alarmist sound bites; mangled grammar and syntax from high officials; avoidance of issues except to delude through misleading references; a focus on scandal and personal faults. Some of these phenomena were common in politics long before the twentieth century, it is true, though the ready availability now of the mass media in all social circles has made them more conspicuous and more irritating. Not only do they reflect the influence of disturbing art, but they are themselves a kind of art form, often kitsch, that shapes and reshapes perception.[14]

These developments in political rhetoric manifestly signal an abandonment of concern for an ideal or improved society; they are evidence, rather, of willingness to distort in order to gain short-term advantages, even though that posture is implicit and is ritualistically denied in explicit statements.

EXPLICIT AND IMPLICIT POLITICAL MESSAGES FROM WORKS OF ART

Chapter 8 explores the theme that direct efforts to influence political outcomes are likely to be less effective than indirect modes, as exemplified in art. In a somewhat analogous way there is evidence that works of art themselves are more effective influences on political beliefs and action when they are indirect and implicit rather than direct or explicit. One major reason for this counterintuitive outcome is that the indirect, implicit political purport of a work of art exerts its effects on ways of conceiving, seeing, and understanding, rather than simply offering a polemical argument regarding a particular policy or action. Art works therefore influence not only beliefs about one current issue but similar ones in other times and settings as well, and they do so in a way that calls

14. For a consideration of kitsch, see pp. 29–33.

upon the audience's own resources to justify the changed mode of conception and action.

Arnold Hauser analyzes a different though related reason for this result:

> The social content of a definite creed or an explicit message is consciously realized by the speaker and consciously accepted or rejected by the hearer; on the other hand, the social motive behind a personal manifesto can be unconscious, and can operate without men being aware of it; it will be the more effective the less it is consciously expressed and the less it appears to be consciously aiming to gain approbation. Nakedly tendentious art often repels where veiled ideology encounters no resistance.[15]

Hauser cites the plays of Diderot, Lessing, Ibsen, and Shaw as tendentious and polemical in this sense, and he contrasts them with the plays of Sophocles, Shakespeare, and Corneille. Both lists could be extended easily, of course, to many artists and to other genres. The contrast appears, for example, in photographs and paintings of Marilyn Monroe. The pictures in advertisements for her films present a beautiful woman and entice viewers to buy tickets in order to see more of her. But Warhol's paintings of Monroe evoke a wide and intense range of attitudes about women, contrived images, desire, eroticism, form, and commercial exhibitionism. These paintings offer an ideology that is broader, deeper, and doubtless more lasting than the sexual attractions of a film star. The direct, explicit appeal, even when it is strong, is likely to be evanescent, engaging with a narrow set of possibilities rather than with the wide range of interconnecting capacities that make us human. That art carries far-reaching indirect effects in no way implies, of course, that it holds the same meanings for everyone.

A related phenomenon complements that one; it involves the distinction between intended and unintended political effects, both

15. Arnold Hauser, *The Philosophy of Art History* (Evanston: Northwestern University Press, 1985), p. 29.

of art works and of other modes of expression. In assessing the personal inclinations and long-term impact of any artist or speaker, it is prudent to pay the closest attention to marginal features of his or her work, for these show the least influence of labored efforts to conform to what is expected or what will be currently welcome.[16] In an insightful paper Lance Bennett has suggested that we learn more about public figures from the gaffes they commit than from their prepared speeches and rationalizations.[17]

THE CONSTRUCTION OF INCONSISTENT MEANINGS

Manet's celebrated painting *L'Olympia* (fig. 2), which shows a nude woman, apparently a prostitute, lying on a couch, is a revealing example of the intellectual puzzles that a work of art inevitably presents. T. J. Clark examines the diverse clues in the painting that have provoked contradictory interpretations. Clark notes that prostitution is a touchy issue in bourgeois society; it involves both sexuality and money, instigating "an uneasy feeling that something in the nature of capitalism is at stake."[18] The resonances of a work of art influence thought about issues that have no direct bearing on its content. *L'Olympia* evokes the attraction of the forbidden and the unlawful, ambivalence toward the desirability of money, and class tensions, especially as those issues have been constructed by still other works of art in all genres.

Clark's rich analysis also calls attention to related meanings of French paintings of the period. A frequent theme was the distinction between city and country life. Paintings of country outings played upon inconsistent reactions to the emergence of capitalism: the association of urban existence with the struggle for adequate income and the aggravations of life in lower-class communities, but also the aspiration of workers to define themselves as bourgeois.

The same diversity, complexity, and inconsistency appears in

16. Cf. W. S. Di Piero, *Out of Eden* (Berkeley: University of California Press, 1991), p. 162.

17. W. Lance Bennett, "Assessing Presidential Character: Degradation Rituals in Political Campaigns," *Quarterly Journal of Speech* 67 (1981): 310–21.

18. Clark, *The Painting of Modern Life*, p. 102.

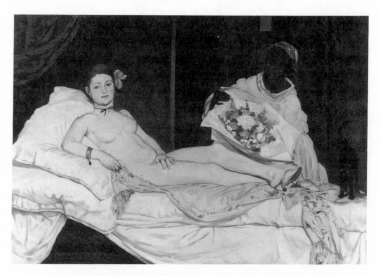

Figure 2. Manet, *L'Olympia* (1863). Musée d'Orsay, Paris.
Courtesy of Artists Rights Society. © photo R.M.N.

novels. In John Steinbeck's novella *The Red Pony,* the ranch that serves as the setting for the action is portrayed as not very prosperous. This condition precludes some kinds of spending that would otherwise be desirable to Carl, its owner, such as allowing Gitano, an old man no longer able to work, to remain on the ranch as he wishes to do because he was born there. Yet the personality of Carl, who "hates softness," is explicitly depicted as the reason Gitano's request is refused. It is, in fact, a common feature of art that even when character and personality traits are recognized as derivative from a social or economic condition, the individual subject is nonetheless seen as decisive so far as praise and blame are concerned. This pattern is manifest, to list some other conspicuous examples, in *Othello, War and Peace* (in which Tolstoy's explicit denials of individual responsibility seem less weighty than the character portrayals), *Death of a Salesman,* and *Oedipus Rex.*

The dynamics are different when an artist portrays human subjects as the loci at which social forces can most eloquently be

27

recognized and understood rather than as self-acting heroes or villains. In an essay on the contemporary painter David Sawin, Arthur Danto makes an astute observation: "Like Henry James . . . whose concern was with characters mainly as points of perturbation in a social field, objects, for Sawin are there for the purpose of making palpable the forces that define a world of paint. In James, one single word can transform the social field cataclysmically, precipitating the tensions it was the mark of his mastery to reveal." [19] The posture toward people and objects that Danto finds in James's novels and Sawin's paintings recognizes that social forces can make themselves known only through their effects on visible entities. It treats entities as foci and signifiers of the forces, but not as their causes; the distinction is crucial.

Diverse and contradictory meanings of works of art are part of what makes them art. Like political actions and public officials, they have no single "correct" meaning, though there is always an impulse toward finding clarity. Meanings are multivocal and subject to change, depending on their context, their content, and the situation of the observer; and they depend as well on comparisons and contrasts with other works of art and with the images they evoke. Sophisticated response therefore involves multivalence and skepticism as key postures. Response is not always sophisticated, of course, so that the range of meanings of relevant works of art is one reason for political argument.

The examples just cited suggest as well that when there is an unresolved conflict among several important assumptions, a work of art may reinforce one of them rather than transform conceptions. It may, for instance, bolster belief in a basic irrationality in making decisions rather than in rationality (Poe, Joyce, the surrealists). As noted earlier, it often defines an individual person as the prime mover while downplaying the role of social structure.

Deliberate omissions of features ordinarily expected in a work of art also construct meanings. This device usually directs attention to the aspects that are present and remain prominent, as it

19. Danto, *Encounters and Reflections,* p. 18.

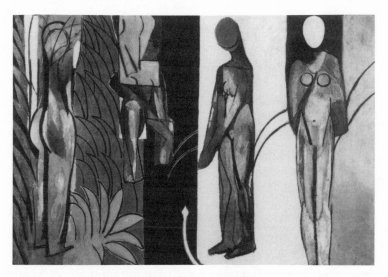

FIGURE 3. Matisse, *Bathers by a Stream* (1916).

typically does in Matisse's many paintings of people with blank faces, like his *Bathers by a Stream* (fig. 3). But when an ensemble requires the missing feature in order to be meaningful, the omission may stimulate audience members to project their own content into it, and so make it especially conspicuous. The most important consequence of omission, nonetheless, probably lies in unself-conscious definition of the phenomenon in question in a selective way, so that alternative perspectives that would emerge from greater inclusiveness do not come to mind.

All these perspectives arising from selectivity and omission, especially the last, are critical in political discourse as well. Chosen perspectives divert attention from alternative ones that would be damaging or embarrassing to powerful groups.

KITSCH

It is not only great art, or even good art, that influences conceptions and perceptions. Art that sentimentalizes everyday experiences, or that appeals to beliefs and emotions encouraging vanity, prejudices, or unjustified fears and dubious successes, is all around

us, and especially so since television became virtually universal. It appears in bad paintings, sentimental romances, and other forms; but popular art is no more likely to be kitsch than any other art. The line between high and low art has typically symbolized class distinctions more clearly than it has marked differences in artistic quality. The line has been eroding fast in the later decades of the twentieth century, though not necessarily as a sign that class differences have been fading as well.

While the long-term effects of kitsch may be weaker than those of better art, it does have a marked impact on everyday life, including political life. Kitsch is a key factor in shaping reality; and with the spread of literacy and the electronic media, its power is certainly increasing. It provides stereotypical models for characters who are admired and those who are disdained. It shapes notions of beauty and ugliness, courage and cowardice, merit and incompetence, honor and shame, and other virtues and vices. It constructs plots about endeavors and perils. It intrigues many people and bores and embarrasses many as well. To review its social functions is to recognize that it plays a major role in politics.

Clement Greenberg suggested that kitsch is debased art that draws its potency partly from its link to authentic art.[20] Its wide influence is therefore still another tribute to the central place of art in shaping social and political life.

False or feigned feelings that win political support are themselves a form of kitsch: bad dramaturgy that works on audiences for a time. Snob culture—fabricated attachment to high art for social and political effect—ranks high in this category. So do the dramaturgical poses of public officials and politicians who display "courage" and "toughness" by requiring *others,* who lack political clout, to suffer in dubious wars that arouse popular enthusiasm in their early stages, or by espousing draconian criminal penalties that have no effect on the incidence of crime, except,

20. For a discussion of this link as well as some other aspects of kitsch, see Clement Greenberg, *The Collected Essays and Criticism* (Chicago: University of Chicago Press, 1986), vol. 1, ed. John O'Brian, pp. 12–19.

perhaps, to increase it through their example of injustice and violence. Kitsch can play with public policies and with personal reputations by evoking spurious fears, hatreds, enthusiasms, and victories.

The worse conditions get, the more effective becomes the strategy of evoking nostalgia or creating enemies (who are often themselves the paramount victims of disturbing conditions). Without widespread poverty there is no incentive to construct the poor as lazy and parasitic. As drug use and abuse grow more common, users predictably become villains who deserve long imprisonment rather than victims of unemployment, disrupted homes, bleak future prospects, and, in some cases, intolerable competition in the middle-class career rat race.

Because emotions based on nostalgia or constructed enemies are easy to arouse, they are strong political influences. Perhaps their most common consequence is to displace attention from disturbing or shameful actions and events. Kitsch, for example, constructs idealized families that rarely or never existed and have a strong nostalgic appeal precisely because real family life has been so different for virtually everybody. Public policies to combat poverty, help minorities suffering from discrimination, or promote careers for women are vulnerable to depictions of a virtuous middle-class family that contrasts with stereotypes of welfare cheats, disrupted families among blacks and the poor, and women who promote careers at the expense of their families. These compelling images divert attention from economic and social policies that have impoverished families, required two incomes for survival, and contributed to divorce, child abuse, poor schools, crime, and increases both in poverty for many and in wealth for some. Political appeals of this kind would be meaningless if the dubious images that sustain them had not already been created and made vivid by television sitcoms and dramas, movies, stories, and romances.

A high proportion of rhetorical references in politics are appeals to false images; they are provoked by dubious art that nonetheless shapes public sentiment and public policies for a time and

that can probably evoke useful insights on occasion as well. Wherever one looks among the issues that excite wide public concern, there is an appeal to fear, nostalgia, class or race prejudice, or other strong emotions, an appeal that is based on doubtful or blatantly false assumptions and contrived narratives. Threats from abroad that justify cold and hot wars are easy to derive from xenophobia, ethnic or racial conceits, and atypical horror stories, all of these echoing a profusion of spurious histories, artful rumors and tales, and deceptive pictures and images.

Kitsch in art depicting social issues can similarly evoke warm sentiment about such characters as the family farmer, who has become scarce because of policies that have enabled farming corporations to drive him into the city. It evokes images of knowledgeable, efficient business managers beset by lazy workers and corrupt unions, and of incompetent government bureaucrats administering wasteful social policies.

To review the wide range of strong sentiment based on kitsch is to recognize that it drives a great deal of public policy. The drive is often in a conservative direction because it is easy to arouse hostilities aimed at the beneficiaries of liberal and radical social policy and foreign policy.

But there is an important oblique exception to the conservative bent of a lot of political kitsch. Its very prevalence makes more authentic images and arguments stand out when they appear on the political scene. Contrasts become arresting. After the country had heard from Herbert Hoover during several years of the Great Depression that prosperity was just around the corner and that local relief efforts were adequate, Franklin Roosevelt's declaration that a third of the nation was ill housed, ill clad, and ill fed and his sponsorship of massive federal relief efforts were all the more dramatic and all the more refreshing. Optimistic claims, in the face of incontrovertible proof that they are false, stop being persuasive and become generally recognized as kitsch.

Rather than constructing a myth, art can call attention to the conditions people actually face, even if those conditions are disturbing or calamitous. Some therefore welcome the message. They

admire *King Lear* for its depiction of greed and brutal treatment of a parent, *Othello* for its harrowing study in jealousy and racial prejudice. Consider as well the pessimistic themes in the works of Steinbeck, O'Neill, Arthur Miller, Balzac, Dickens, and the Greek tragedians—and, indeed, in a high proportion of great art in most genres. In such works, life is analyzed with insight and not romanticized. Insofar as they have political consequences they contribute to realistic policies rather than to intensification of problems and blame for the vulnerable.

Implicit in much of this discussion of kitsch is the recognition that it plays upon observers' hopes and fears and asks only for a passive response from them. It is easy and syrupy. It does not postulate an observer with an active mind, with the imagination and creativity to grasp a work's potentialities. The same distinction holds for various forms of political discourse. Indeed, its manifestations in art doubtless help call attention to its appearances in politics.

The banality, predictability, and long-standing tensions of many aspects of daily life both evoke ritualized political language and reflect it. Spurious art can alleviate, romanticize, or embellish this unfortunate characteristic of modern culture, which both echoes and in some measure masks daily exasperations and conflicts. W. S. Di Piero makes the point: "Beneath . . . increasing material uniformity and standardizing, which were hawked to consumers with the ruthless cheer that is American advertising's most salient tone, there were old hatreds, resentments, and failures of faith that ran along racial and class lines."[21]

As in some other examples noted elsewhere, everyday experiences, political language, and bad art create and reinforce each other, stabilizing an unfortunate set of social relationships, but in time stimulating some artists and some audiences to turn to art to alter the static situation.

21. Di Piero, *Out of Eden*, p. 145.

Art: Meanings, Constructions, Threats

ART AND TECHNOLOGY

Walter Benjamin's perspicacious observation that technology changes the function of art[1] sounded a theme that has continued to concern and intrigue artists as well as art theorists and critics. Benjamin suggested that mechanical reproduction removes the "aura" from works of art and at the same time makes them immediately political. He presumably meant that art, once it becomes easily reproducible, readily conveys to mass audiences the kinds of political implications that politicians espouse on specific issues. In a similar vein Herbert Read argued that alienation is critical to art and artists and saw technology as undermining alienation and therefore invalidating "the very substance of art."[2]

The crucial issue, of course, is the nature of the link and of the divide between artists and everyday affairs. Benjamin and Read are certainly justified in seeing art as fundamentally detached: as reflecting a human capacity that draws its power from its reflection of needs that do not necessarily have an immediate bearing on the social scene in which people regularly play their parts. They are right as well in recognizing that technology makes it possible, and therefore politically expedient, to break down the detachment by using art to further political designs and so undermine its character as art. Bertolt Brecht believed, similarly, that art establishes a "Verfremdungseffekt" which sets up a mental conflict between

1. Walter Benjamin, "The Work of Art in the Age of Mechanical Reproduction," in *Illuminations* (Schocken Books, 1969).

2. Herbert Read, *Art and Alienation* (New York: Schocken Books, 1966), p. 30.

its meaning and what is accepted as rational in everyday life. And Herbert Marcuse saw art as a "subversion of the positive" through its form, its language, or its treatment of subject matter.[3]

Yet the detachment that art provides is necessary to render existence worthwhile, as the ubiquitous presence of art in all times and cultures certainly signifies. For reasons examined in other sections of this book it furnishes conceptions that are provocative and challenges conventional suppositions, and so can contribute to mental alertness and accomplishment.

What, then, are the consequences of the deterioration or erasure of art as a goad when technology comes to dominate human affairs and subverts at least some art so as to give it a strong political thrust that can overwhelm its "aura"? Perhaps that development impoverishes thought and feeling in some measure.

The consequences for politics are more certain, if less fundamental. Mechanical and electronic reproduction offer a large arsenal of new weapons for political deployment. Subverted art forms in various guises and in diverse media now politicize virtually the entire population, often in ways that corrupt political debate and reflection. Much, though far from all, of the art involved in this process becomes kitsch, politically potent but intellectually and emotionally vapid.[4] The socialist realist art of Eastern Europe during most of the twentieth century may be the prototypical example, but Western culture is permeated as well by much of the art exploited in advertising commodities and candidates and the art appearing in magazines, books, and many television dramas that not too subtly disseminates notions about which kinds of people, actions, and occupations are trustworthy and which suspect or undeserving. In this way art may reinforce political repression.

But great art readily serves political purposes even when it is not itself explicitly political. Edward Said has persuasively argued that many of the novels (by Dickens, Forster, Conrad, Brontë, Austen, and others) and some of the poetry, plays, and operas of

3. Ibid., p. 33.
4. For a discussion of kitsch, see pp. 29–33.

the last two centuries reflect ideas about the inferior talents of third world peoples, thus rationalizing imperialism.[5] Such political effects, whether deliberate or unintentional on the part of the authors, manifestly depend on the technological ability to reproduce and spread the works of art in question. The novel and the film are, of course, inconceivable without means of mechanical or electronic reproduction.

Quite apart from their textual content, the classics of the past come in time to serve as commercial messages, as Herbert Marcuse pointed out. Familiar as cultural landmarks and carrying high status, they are no longer alienated, but are, rather, "incorporated into this society and circulate as part and parcel of the equipment which adorns and psychoanalyzes the prevailing state of affairs. Thus they become commercials—they sell, comfort, or excite . . . they are deprived of their antagonistic force, of the estrangement which was the very dimension of their truth."[6]

Marcuse's point is perceptive, but it probably should be qualified by taking some account of the subjective reactions of observers, rather than assuming that classics undergo the transformation he describes for everyone. It seems probable that audiences can assume a frame of mind that focuses on the antagonistic force and the original aura of a classic work of art rather than on its status as a familiar war-horse. If so, the political uses of classics have to be explored in each encounter rather than taken for granted.

That suggestion very likely applies to Read's contention about estrangement and to Benjamin's about aura as well; and it carries a corollary meaning with it. The work of art that bears the aura and is estranged or antagonistic to conventional presumptions also serves a political function, albeit a different one from the same work after it loses those properties. It is the difference between a *Guernica* that undermines our accepted notions of the

5. Edward W. Said, *Culture and Imperialism* (New York: Knopf, 1993).

6. Herbert Marcuse, *One-Dimensional Man* (1964), pp. 61–64; quoted in Read, *Art and Alienation*, p. 30.

necessity and utility of war and a *Guernica* that simply becomes one more argument against fascism and the bombing of civilians as an unfortunate incident of war. It is the distinction between an *Antigone* that shows the usual assumptions about the virtues of the state to be cant and an *Antigone* that simply becomes one more argument against tyranny or arbitrary action by the powerful. But while the original, antagonistic force of a classic bears a more radical purport, its audience is minute compared to that of the same work when it has become banal through wide dissemination.

Clearly, then, perception cannot be either objective or innocent. It hinges on whatever is taken for granted, on what is expected, and on ideology respecting controversial matters. Read reminds us, moreover, that "the eye is thoroughly corrupted by our knowledge of traditional modes of representation, and all the artist can do is to struggle against the schema and bring it a little nearer to the eye's experience."[7]

Of course, the artist contributes considerably more than that so far as political impressions and political effects are concerned. In struggling against the traditional mode of representation and finding a new one, he or she can create images and insights that greatly enhance the political vision that is embraced, even though the point of view itself may not be new. The visions of war in the works of Picasso, Goya, Brecht, Shakespeare, and many others shape modern beliefs and even the modern experience of war because the artists present the topic compellingly, with haunting insights that go beyond the conventional ones. The same point applies to every other significant experience and issue.

Kitsch also offers perspectives on these topics and can exert strong political effects that may be decisive at times. But it does not ordinarily bring transformations in perception and experience that last through successive generations and in radically different situations.

7. Read, *Art and Alienation*, p. 71.

A FOCUS ON POLITICAL OUTCOMES

Political discourse deals largely with competing influences on policy, the processes in which they play their parts, and arguments about their relative merits. But in the last analysis art shows, conceptualizes, and reflects upon chiefly the *outcomes* of social processes. The distinction is not clear-cut, but it amounts to a marked dissimilarity in emphasis and usually in purpose.

This divergence between the two modes of expression is all the more important because the focus on process in political language is frequently misleading about outcomes; hostile groups have every incentive to distort claims about the effects of their efforts. Such misrepresentation is quite different from the inevitable focus in works of art on particular aspects of an outcome. A performance or a reading of Brecht's *Mother Courage* casts no light on the exhilaration some soldiers may feel in battle, as *Henry V* does, but it offers an unforgettable depiction of the seamy side of war and the suffering it brings to civilians. The language of war hawks, by contrast, consistently exaggerates the threat that an alleged enemy poses and the likelihood that a war will solve problems, while at the same time minimizing its costs and the hardships it brings for both soldiers and civilians. The importance of such political language lies in its influence on support and opposition, not in its contribution to understanding, or even misunderstanding, the outcomes of war.

More generally, great artists' serious reflections upon outcomes are likely to override their political language and rationalizations for particular courses of action in the minds of their audiences, even when the art they produce incorporates such rationalizations. *Mother Courage, Guernica, All Quiet on the Western Front,* and *Henry V* are classics not because they embody powerful arguments for or against war but because of their artistic merits. None of the propaganda for or against particular wars, on the other hand, is likely to be read for very long—except, in a few cases, as especially outrageous examples of lying.

The point is evident in the writings and paintings of a great

many artists; to name them is to exemplify the worth of artistic conception and to see the policy argument as ancillary. Consider the works of Tolstoy, Dickens, Munch, Mishima, or Kollwitz as ready examples, though virtually any work of art could serve as well. Balzac and Dostoyevsky portrayed political dissenters sympathetically in their novels, as the situations they pictured required them to do, even though both novelists were political reactionaries.

As art portrays outcomes, it characterizes social situations, personal hopes and fears, and fantasies, whether or not these have any bearing on political decisions. Indeed, imagination, distortion, dreams, and explicit fiction may constitute the most unforgettable studies of outcomes, for they reflect and enrich the meanings of situations and of reactions to them. The witch scenes in *Macbeth* are superb studies in the fears and aspirations that animate overweening ambition. *Don Quixote* is a phenomenal portrayal both of the romanticism that had helped sustain knighthood as an institution and of the reasons it was dying in the fifteenth century.

A related sense in which art deals with the outcomes of social processes is its power to focus on an explanatory configuration and so make sense of a set of observations that would otherwise be chaotic or else take on more idiosyncratic meanings. In writing and, even more clearly, in reading or hearing news reports and statements of public officials and interest groups, and in interpreting past and current events, people can take account of only a small fraction of the situations and happenings that are relevant in time, in space, in logical connections, or in some other way. The selection of the fraction and its form as a meaningful picture or narrative is shaped by works of art that are relatively familiar. Victory or defeat in battle, heroic or tyrannical leadership, hostile or friendly relations with foreign nations, the suffering or the laziness of the poor, help or frustration from bureaucracies, conspiracy, altruism—all find their models in well-known works of art. These shape perception and public reactions, and advocates for particular courses of action tap the beliefs and emotions they

evoke, whether or not they are explicitly cited or recalled. Works of art are likely to be compelling in their effects, while observed and reported "facts" are ambiguous and complex and therefore become stimuli to resort to the credible explanations and models that art provides.

Where controversial issues are involved, there will, of course, be conflicting or divergent models from which to choose, but the set of influential possibilities is likely to be small. The model a group or individual chooses shapes what is perceived, recognized, and ignored and how it is interpreted. Interpretations influenced by art accordingly construe the outcomes of political acts, for the meanings and implications of outcomes are not self-evident.

What were the meanings and implications, for example, of the fall of the communist regime in the Soviet Union, one of the more momentous political outcomes of the twentieth century? It can be fitted into any of the following patterns: communism versus market economies; a replay of many other coups in Russian history; bureaucratic mismanagement; the mistakes of the fallen leaders; and doubtless some others. Each scenario has long since taken its meaning from novels, historical romances, films, and paintings that have helped shape the modern mind.

Current as well as past conditions, events, and anxieties make people susceptible to particular ways of seeing and understanding realities, including the outcomes of political processes. Behind whatever takes place people learn to perceive divine will, human reason, unconscious impulses and needs, accident, or other phenomena. It is artists who provide the ways of seeing, the categories, and the premises that yield modes of understanding everyday life. Twentieth-century art has been especially explicit in revealing the premises that have dominated contemporary thought. The wars, genocides, homelessness, and other conspicuous public events of the century have inspired a great deal of shock, fear, and outrage, which works of art have objectified and so made more readily available for expression in everyday activities and political statements.

Dada was, among other things, a protest against the horrors of

World War I, and surrealism was in part a reaction to the dark and irrational impulses that were increasingly prominent in society and politics, all the more alarming because of their negation of the optimistic premises of the nineteenth century about human reason and progress. Kafka and other writers were simultaneously revealing the same ominous potentialities, as Freud had done earlier in writings that were more clearly art than science. Nietzsche saw art as a refuge and compensation from the terrors of life: "Where we encounter the 'naive' in art, we should recognize the highest effect of Apollinian culture—which always must first overthrow an empire of Titans and slay monsters, and which must have triumphed over an abysmal and terrifying view of the world and the keenest susceptibility to suffering through recourse to the most forceful and pleasurable illusions."[8]

On learning of the execution in Mexico of the Emperor Maximilian in July 1867, Flaubert wrote to the Princesse Mathilde: "It is in order not to think about the crimes and stupidities of this world (and not to suffer from them) that I plunge myself headlong into art: a sad consolation."[9]

After the Holocaust proved that the horror could be even more alarming than most people had envisioned, painting, dance, and writing taught twentieth-century human beings a set of avenues through which they could react, ranging through meaninglessness, obscurity of meaning, tapping of the mind's unconscious processes, hedonism, the application of reason to unreason and vice versa, and so on.

A complementary outlook on this issue comes from considering how propagandists win support and how art can change that outcome. The key strategy in political infighting is the presentation of an issue so that a chosen perspective emerges as the compelling one. The nationalist viewpoint, or that of industrial management,

8. Friedrich Nietzsche, *The Birth of Tragedy* (New York: Vintage Books, 1967), p. 43.

9. Quoted in Julian Barnes, "The Mystery of a Masterpiece," *New York Review of Books* 40 (April 22, 1993), p. 27.

or that of women or the military services, becomes the critical perspective. But cubism teaches that alternative points of view are always present, consciously or latently. Other art forms present alternatives to the conventional position as well, because works of art are always subject to diverse interpretations.

Fear of Art

From the time that Plato urged banning artists from the ideal republic, and probably earlier, fear, distrust, and resentment of art and artists have been key political influences, especially in states whose rulers had reason to distrust the populations they governed. Recurrent opposition to artistic freedom and repeated attempts to harness art to serve the ideological goals of the state and the status of rulers are evidence of a widespread recognition that art shapes public perceptions of the legitimacy of the state, public morals, and behavior: that it is therefore a central influence on support for and opposition to political acts, rulers, and dissidents.

In democratic states the issue of governmental support for or opposition to art is often contentious. Many recognize that governmental subsidies are necessary to keep art flourishing, and believe that artistic freedom is a prerequisite to a democratic and healthy society. Others, likely to feel more intensely about the issue, may have little interest in art as a social benefit but are outraged by particular works that seem to them to challenge moral standards and the bases of a respectable society. For the latter group the political implications of art are paramount, and they correctly recognize that some art rejects and perhaps threatens conventional notions of respectability. Some of the work of Robert Mapplethorpe, for example, excites fear of unrepressed sexual behavior, of desecration of myths respecting the sacred, and of anarchy, though not in people who are secure about their sexual orientations, nor in people who recognize the constricting potentialities of notions of the sacred and of emotional dedication to "law and order."

Fear of art is even more conspicuous, and more consistently a component of public policy, in nondemocratic states. Fascist gov-

ernments, those headed by a dictator, and the Stalinist regime in the Soviet Union have all placed rigorous restrictions on writers and painters and have demonstrated a strong bent toward puritanism.

Such attacks on art have always taken place; they recur in the twentieth century in all states, partly because a number of art movements of recent decades have explicitly or subtly assaulted basic social institutions, and partly because such assaults may look especially dangerous in an age in which the general public's access to art is easier than it has ever been before. A significant number of twentieth-century artists have reacted strongly against the ties of earlier art to elite institutions: aristocracy and royalty, bourgeois society, capitalism, governments dominated by these institutions, and moral codes that reflect their interests and biases.

That an artist's rejection of convention and dominant ideology in this way should seem so dangerous to some is a revealing phenomenon. It suggests that those who try to suppress such unconventional art, like Senator Jesse Helms, see it as a blight that will spread and undermine what they regard as a good society. In light of much of the argument of this book, such a belief may well be correct. Works of art do influence or reinforce ways of seeing, fundamental assumptions, and forms of belief, skepticism, and cynicism. Art establishes and changes the parameters within which behaviors, institutions, and policies are approved, criticized, or condemned. It is a major political force, then, especially through works that are not explicitly political, and even though its political thrust is ordinarily masked. At the same time, art can reinforce established institutions and beliefs about morality, as noted earlier.

Suspicion of artists and antagonism toward them are probably always present, at least in latent form. The artist seems to represent a life that is not constrained by the conventions other people are expected to accept. Her profession requires that she be able to think freely and show what she thinks publicly, even if it is unpopular or unfashionable. She is therefore disturbingly unpredictable regardless of what her work is like.

To make this point from a slightly different perspective, the very production and existence of art encourages skepticism about

the pieties of regimes, elites, and the "respectable" because art is so often ironic toward these groups, or because it constructs realities and so demonstrates how readily that can be done.

Art therefore may question the validity of the official or commonly disseminated version of reality, a validity the presumption of which is necessary to satisfied acceptance of the status quo. It may suggest, usually subtly, that that version is closer to propaganda, intimidation, or a self-serving construction. To cite just a few recent examples, the paintings of Matisse often show a reality under the surface appearance.[10] The appearance of respectability and devotion to law portrayed in *The Crucible* is shown to conceal blatant prejudice, self-serving economic transactions, corruption, and hysteria; so Arthur Miller's play influences opinion respecting contemporary prosecutions for child abuse that rest on the same frail foundations. In this sense art is likely to advance elemental meanings that are sometimes obscure but underlie surface appearances.

The encouragement of skepticism regarding the justification of the existing social order is most threatening to elites when old values are breaking down and there is uncertainty about what function regimes and elites play in influencing the general public. Governments understandably become suspicious and fearful of art and artists at such times. Efforts at censorship and suppression of unconventional art are certain to emerge and to attract some fervent support.

IMAGES AND UNDERSTANDING

The images art provides are always ambiguous in some measure, just as every prose sentence is ambiguous. Art is especially enigmatic when it provokes thought and understanding, and least so in works that serve explicitly as political propaganda, such as so-

10. Cf. the text by John Elderfield accompanying the catalog for the exhibition "Henri Matisse: A Retrospective" (New York: Museum of Modern Art, 1992), p. 163.

cialist realist art and fascist depictions of enemies of the state. In this sense clarity signals the closure of thought, as the poststructuralists have recognized.

That there is inevitably mystery at the core of art helps explain why it repeatedly addresses a set of the same familiar themes. These are issues that perpetually excite concern, fear, or hope and that cannot be resolved. They are therefore the themes that sophisticated and keen minds are always ready to confront, precisely because there are no ready solutions, but rather constant challenges in the light of changed conditions and understandings. In facing them from fresh perspectives, minds are sharpened. Art often offers such perspectives, just as political discourse typically offers banal and predictable statements and responses. A critical link between art and politics may abide in this contrast, for the mind that finds predictable and ritualized contests tiresome can turn to art for relief.

THE CONSTRUCTION OF WOMEN
THROUGH WORKS OF ART

Every aspect of our lives and our perceptions of the world depends on art in ways that are largely overlooked. To examine more closely the influence of art on such fundamental features of our worlds, consider, as an example, common beliefs about women that lend themselves to political uses in contemporary society.

As portrayed in works of art, and as typically discussed by men, women are frequently one or all of the following entities, and others as well: an ideal (as Eve, as Mary, and as goddess); property, to be used and abused in order to enhance the well-being of males, materially and as display; a readily available outlet for aggression; a nurturant aid to others; a threatening and potentially powerful competitor, showing greater skill than men at many enterprises, including some generally regarded as male preserves; a tougher and more durable species than men, living longer and typically coping better with hardship, both psychologically and physically; a weaker and more vulnerable species than men,

especially as constrained and shaped by laws, traditions, conventions, and physiology, and therefore an easy outlet for sadism and a tempting one for masochism.

All such meanings of woman as symbol are learned or conditioned largely because they are presented that way in works of art and literature: novels, paintings, photographs, stories, movies, television dramas and sitcoms, cartoons, off-color jokes, and so on. These constructions, rather than direct experience with women, are critical, for the meanings of daily experiences are themselves constructed from such works of art.

Symbolic woman, then, is threatening, fascinating, and romanticized.[11] That perspective helps explain why gender is crucial in assessing women in politics. The meanings just listed create strong multivalence about women, so that women in politics can play to some of them (e.g., Margaret Thatcher and Golda Meir as tough; Patricia Schroeder and Cleopatra as Eve and as vulnerable); and chauvinists can also gain advantage from some of the disturbing or threatening ones. There is doubtless an undercurrent, partly conscious, partly subliminal, of all of them in reactions to all women, even on the part of those who know better. So far as politics is concerned, the dominant note may be threat. In any case, both men and women react to the images of women that art creates, rather than to reality in any other sense.

THE RECONSTRUCTION OF LIVING CONDITIONS THROUGH ART

To contrast experience to art is misleading if, as some earlier passages have suggested, art helps *shape* experience of daily life. If the meanings of common experiences come in large part from the archetypes familiar from art, then living conditions are subjective

11. Symbolic man is also a product of art, of course, but with meanings that overlap only partly with these and in many respects depart from them substantially.

My discussion of the artistic construction of women benefited from a paper by Virginia Sapiro: "The Political Uses of Symbolic Women: An Essay in Honor of Murray Edelman," *Political Communication* 10 (April–June 1993): 141–54.

phenomena, susceptible to construction and change even when they remain objectively stable.

In his study of painting in nineteenth-century France,[12] T. J. Clark offers a number of observations that illustrate the point. After describing Haussmann's transformations in those years of the layout of the city of Paris, focusing on the construction of broad boulevards while demolishing many of the communities of the petite bourgeoisie and the poor, Clark remarks that the city "still belonged to those who lived in it, . . . but simply as an image."[13] From that time onward the Parisian boulevards have been a spectacle, for residents as well as visitors: one that could be "passively consumed" and that reflected and reinforced distinctions of class, age, sex, and character. Clark notes that Manet and the modernists painted the boulevards as places of pleasure for the eye, "but in such a way as to suggest that the pleasures of seeing involved some sort of lack—a repression, or alternatively a brazenness."[14] Part of the lack, clearly, was their blurring of distinctions of class, age, sex, and character. Clark notes that in the spectacle, though not in everyday life, the classes seemed to belong together and have common interests.[15]

To aestheticize familiar settings that serve a vital function is to exercise a form of control of populations that may be subtle, as in this example, or may be blatant, as in the conspicuous fascist reliance for popular support on festivals, rituals, and myths in the 1930s.[16] The Nuremberg festivals and other celebrations of Nazi power constructed a mythical paradise of heroes and a mythical hell for their enemies that diverted attention from everyday struggles and problems and created general enthusiasm for the Nazi rulers and their policies, no matter how difficult or odious they would have seemed without the cynical translation of

12. Clark, *The Painting of Modern Life.*
13. Ibid., p. 36.
14. Ibid., p. 78.
15. Ibid., p. 205.
16. For some detailed examples of the phenomenon in contemporary America, see chapter 6.

repressive governmental operations into spectacle.[17] In a similar way, monumental public buildings and great cathedrals, temples, and mosques create a Wittgensteinian language game in which a mythologized set of higher powers and their demands win attention and support while the concerns of everyday living fade from the experienced universe.[18] In this respect, then, the festivals and the monumentality are political tactics rather than art because they encourage a particular perspective rather than diverse interpretations, though the same buildings may be artistically significant in other aspects.

The Construction of Inconsistent Meanings

Everyone who appreciates the arts becomes aware that each painter, writer, or musician is likely to be sensitive to a particular aspect of the world and to bring it to attention repeatedly in his or her work. The sensitivity may be to the pain, humor, or emptiness in relationships with others; to links to nature; to the threatening or rewarding character of the environment and of social settings; to the tragic, humorous, erotic, or gratifying prospects people face; to the significance of the supernatural or of God; or to the importance of the unconscious. Exceptional perceptions of these kinds are doubtless a large part of the explanation of what it is that makes a person an artist. Simply to name well-known artists is to illustrate the point at once; consider, for example, Chagall, Klee, El Greco, De Chirico, Tanguy, or Munch; Poe, Whitman, Dickens, Dostoyevsky, Tolstoy, or Cervantes; Beethoven, Haydn, Wagner, or Handel. Each of these artists displays a rather consistent outlook that is recognizable to audiences and that helps educate and sensitize those audiences to particular realities. A smaller set of artists offer a wider range of perspectives in their work: Shakespeare, Goethe, Mozart, Bach. Perhaps the ability to do so is part of what makes these last figures especially great.

17. For a careful review of the function of myths and rituals in the Third Reich, see George M. Mosse, *The Nationalization of the Masses* (New York: Howard Fertig, 1973).
18. Cf. chapter 5.

We view the world through the lenses these various perspectives provide. Without them our lives would at best be impoverished. Although the perspectives spring from material conditions, art helps us experience them more fully; and because it provides a diverse range of them, the perspectives change in accordance with current hopes, fears, and prospects.

Indeed, it is very likely exposure to works of art that makes it possible to feel and understand the emotions associated with particular situations.[19] Could we feel and understand love, empathy, anger, fear, sadness, and other emotions as we do if we had not first been taught about them and sensitized to them in books, paintings, and other art forms? There is doubtless a biological basis for such emotions, but how and when they are manifested is bound to be largely learned: the situations that evoke them, the modes of their social expression, even the feelings that we teach ourselves are associated with them. It is true that exposure to the art from which we learn about them is often secondhand, and sometimes that art is kitsch, which doubtless cheapens the felt emotions. Here, then, is still another major sense in which art is central to perception and conception. Directly or indirectly, political discourse draws on one or another such perspective derived from art, the specific outcome depending on the motives and the outlook of the speaker or writer.

THE SANCTIFICATION OF IDEOLOGY THROUGH ART

Arnold Hauser distinguishes between writers who explicitly express their ideological views in their work (Shaw, Ibsen) and those who indirectly assume an ideological stance by examining a range of revealing social situations (Shakespeare, Corneille, Goethe). Hauser argues, doubtless correctly, that the second approach is the more powerful way to influence audiences.[20] Explicit advancement of an ideological position can, of course, be highly persua-

19. Cf. Suzanne Langer, *Philosophy in a New Key* (Cambridge: Harvard University Press, 1970).

20. Hauser, *The Philosophy of Art History*, p. 29.

sive when eloquently done, but it also elicits doubts and rebuttal, as any political argument does, and it invites dissenters to ignore both the argument and the work of fiction in which it is embedded. By contrast, indirect establishment of a point of view on a political issue encourages audiences to understand the author's position even while attending chiefly to the artistic value of the work in question. Because it subtly derives the political outlook from relevant moral, social, economic, and psychological premises, its ideological thrust is likely to be deeper and more lasting. The distrust in government repression derived from *The Bacchae, Coriolanus,* or *Guernica* is more fundamentally based than a polemic against misuse of governmental power in *An Enemy of the People* or *MacBird.*

Both forms of artistically promoted ideology define people as either oriented politically in a praiseworthy way or as misguided, dangerous, or diabolic. But the implicit incorporation of an ideological position is likely to mean that the political message and its ramifications respecting virtue and vice are both more memorably imprinted on the mind and more readily accepted.

What of the art that deals with private lives, troubles, and triumphs with no apparent political connection: Matisse's nudes, still lifes, most Dinesen tales, classical dance, and many other works? Sometimes there is an implicit political connection, as when governmental actions themselves create the poverty, inequality, corruption, vanity, or beauty that the art deplores or celebrates. More often, probably, the thrust of such art is to focus attention on the importance to human beings of their nonpolitical concerns and interests. Even in these cases such a focus can carry strong political associations: the message, for example, that politics is a relatively trivial concern most of the time, or that it can be an unfortunate intrusion on what people want to do with their lives.

Consider as a polar example the insistence of totalitarian states that people devote their time and attention to politics to the exclusion of personal gratifications. There are some efforts in that direction in democratic states as well, chiefly by portraying political activities as a civic duty. The ability of officials to reach the entire

population easily through the mass media makes such ventures more menacing now than they were before the twentieth century. The private sphere is a refuge that everyone needs. Government is an omnipresent threat to it, while nonpolitical art is an acute reminder of its value.

Sometimes first-rate art enhances an ideology by endowing it with a compelling aura. The adept employment of chiaroscuro helped medieval and some later artists to create a religious ambience. As Danto put it, "Their strategy was to heighten feeling by enabling the light to fall from an almost mystical source upon the figures it touched."[21] This device is conspicuously absent in modern secular and explicitly political art, except in occasional kitschy depictions of favored or demonized groups.

In the twentieth century the close historical association between established art and established political power and inequalities has produced a backlash among artists against both institutions, especially among devotees of dada, surrealism, and late-century efforts to violate conventional constraints and conventional views of morality. Good art and the institutions that foster it have come to be seen in some influential quarters as supports for political oppression.

These movements have engendered an array of devices for debasing art as an institution in order to make a subversive political point. To paint a mustache on the Mona Lisa, as Duchamp did, and to replace white faces in masterpieces with black ones, as Robert Colescott does, are efforts to force audiences to think about their conventional ideological assumptions respecting status and social inequalities and the buttressing role of art in both.

21. Ibid., p. 220.

Art: Transformations and Challenges

THE TRANSFORMATION OF CONCEPTIONS
THROUGH ART

Commonly held assumptions about the nature of the world are partly arbitrary, partly conventional, often contradictory, only rarely based on verifiable tests, and even in the last case likely to change as scientists revise their premises, hypotheses, and techniques of observation. Successful works of art enhance, destroy, or transform common assumptions, perceptions, and categories, yielding new perspectives and changed insights, although they sometimes reinforce conventional assumptions as well. They can transfigure experience and conception, calling attention to aspects and meanings previously slighted or overlooked.[1] They "participate in our continual remaking of a world."[2]

Works of art are critical in generating powerful conceptions because they provide insights that are closely linked to emotional responses and are therefore likely to reappear in similar situations. Part of the meaning of artistic talent is the ability to sense feelings, ideas, and beliefs that are widespread in society in some latent form, perhaps as deep structures or perhaps as unconscious feelings, and to objectify them in a compelling way. Medieval paintings of the saints and of biblical scenes evoked new or heightened religious responses that involved both feelings and altered conceptions. For many generations *Antigone* has directly or indirectly taught the Western world something fundamental about the opposition between individual codes of moral conduct and the de-

1. Cf. Nelson Goodman and Catherine Z. Elgin, *Reconceptions in Philosophy and Other Arts and Sciences* (Indianapolis: Hackett, 1990), p. 22.
2. Ibid., p. 48.

mands of the state, while also evoking powerful feelings. In this sense art involves both feeling and the examination of feeling from a distance. That view is consistent with Suzanne Langer's conclusion that art brings "understanding of emotion,"[3] and it helps explain the potent and lasting influence of art on both thought and feeling.

This conceptualization emphasizes the dependence of the artist on social influences, past models, and economic possibilities. It is because those links are central and wide-ranging, and also because the artist's biography and social situation prepare him or her to take advantage of them, that the work of art reflects latent possibilities with particular effectiveness. This view rejects totally the notion of the artist as a unique creative genius operating apart from society.[4]

There is manifestly no simple relationship between art and assumptions about politics and other transitory developments. They reinforce each other, take cues from each other, and conflict, at least briefly. But for reasons suggested earlier, trends in art are the more basic development, reflecting ideas, aspirations, and anxieties that mark particular historical periods and geographic regions.

Art frequently evokes sensibilities that are otherwise masked. It also helps us recognize how arbitrary conception and perception typically are. To read *Macbeth* is to perceive ambition and remorse in a way that will influence future references to those sentiments, and at the same time to become aware that they can be aroused and influenced by a wide range of cues and circumstances. To view many El Greco paintings is to conceive the world and the heavens thereafter in a more ominous and threatening light than that in which they had earlier seemed to stand, and also to become attentive to what brought about the change.

From ancient times art has been perceived as a generator of

3. Langer, *Philosophy in a New Key.*
4. For an admirable examination of this issue as well as the place of the subject in social action see Wolff, *The Social Production of Art.*

moral transformation. Plato saw it as so powerful a force in converting viewers into what they saw in works of art that it had to be under the rigorous control of the state and a major consideration in educational planning.

CHALLENGE TO CONVENTIONAL ASSUMPTIONS

Conventional political assumptions, for obvious reasons, tend most of the time to reassure or to encourage quiescence. They are likely to be optimistic regarding the lives people lead when they have little choice; they are therefore banal. They tell us that existing conditions are desirable or inevitable, that leaders are powerful, benevolent, and beneficial, that adaptation and conformity are signs of mental health, that enemies will be contained or overcome, that justice and peace will arrive—eventually, if not now. But their conventionality and their intrusion on the mind without analysis and reflection can also make them stultifying.

Although works of art may reflect such perceptions and make them vivid, they can also undermine them in the measure that those works become a significant part of the cultural heritage. They are art precisely because they move perception and thought away from the banal and the conventional. A sensuous Matisse painting, such as *Le Bonheur de vivre,* also teaches an audience that sensuousness is a creation of the artist and the onlooker rather than an attribute of nature. That contribution is a critical part of the distinction between a Matisse and a sensuous picture in a girlie magazine, and both kinds of depictions influence receptivity to statements about women. Even while portraying tyranny in *Richard III,* Shakespeare helps us understand the character flaws and insecurities that create the tyrant.

Departures from accepted suppositions stimulate the faculties; and when works of art incite such departures, they show us as well that the separate categories "cognitive" and "emotional" are not distinct, but rather aspects of one another. Accepted suppositions, moreover, are themselves frequently the creations of works of art that later art challenges. The idealized portrayals of the human figure that characterized the High Renaissance in Italy were

departures from the depictions of religious striving and suffering presented vividly in medieval painting and sculpture.

In time the great work of Raphael, Giorgione, and other early Renaissance artists produced a reaction: a new movement in art and literature, mannerism, that replaced idealized representations with distorted human figures, sometimes with shocking fantasies, often with horrors, and with a new emphasis as well upon stimuli to the mind and the imagination; so that European art now produced the marvelous creations of Michelangelo, El Greco, Tintoretto, Brueghel, Cervantes, and Shakespeare. In our own disturbing time a great deal of art focuses on pathetic and tragic alterations of the ideal as well; consider Henry Moore, Käthe Kollwitz, James Joyce, expressionism, and poststructuralist art.

Mannerist, expressionist, and surrealist paintings do not imitate nature any more than the paintings of the High Renaissance did. But they often render their subjects "hyperreal" in the sense that they become more vivid and more memorable than the objects of everyday observation. The mannerist paintings of women and of landscapes and cityscapes, like Matisse's paintings of the same objects, create a kind of fairy-tale world, or sometimes a paradisal or demonic world. It is always apparent that it is a subjective world as well. Its function is to provoke: provocation that is bound to influence political action and political rationalization profoundly. The art can instill the images of officials, bureaucrats, heroes, villains, and issues that drive political action.

Images of the potentialities and the problems of human nature and of the worlds that humans inhabit and create, the interactions of reason and emotion, and the capacity of works of art to shape perceptions of achievements, challenges, and failures are instances of the transformative powers of art that underlie more evanescent political beliefs, those that form the basis of explicit views about politics, policies, and the choice of leaders. Art that portrays anguish and bewilderment, for example, as much of mannerist painting, literature, and drama does, must encourage a politics that reflects or confronts that condition. It disseminates ideas of war, famine, poverty, oppression, and cruelty.

In that respect works of art build a kind of understanding of everyday life, including its tragic aspects, that is indistinct until it is objectified in revealing images. *King Lear* evokes and places in perspective pathologies that readily invade the family and the state: greed, unjustified credulity, envy, and cruelty among them. *Death of a Salesman* offers understanding of the intimate link between personal health or illness and social conditions. Salvador Dali's paintings, like those of many other surrealists, offer insight into the fantasies and fears that shape people regardless of volition. We normally see experience as the generator of fundamental political stances, but the meanings of experiences take on the configurations that art gives them, and art can make us doubt them or change them.

By the same token it can transform or muddle the meanings of celebrated, well-known symbols. In a number of paintings of the American flag (see fig. 4, for example), Jasper Johns seems to see the flag as an enclosure that hems people in or as the controlling feature of the environment rather than as a symbol of national glory. Plainly, art can transform common objects with well-defined meanings into something different. Robert Frank uses the flag to accentuate the pathos of solitary lives. Of Larry Rivers's painting *Washington Crosses the Delaware*, Di Piero has written: "The spotty, nebulous brushwork and the drawing that shows through the half-realized figures like wiring enact not a historical event so much as a skepticism about the way history's tones are determined by stylized facts."[5] That skeptical response to conventional patriotic themes has become a conspicuous feature of public sentiment in many contemporary circles.

Inherent in such observations is recognition that art is often subversive of conventional assumptions, of what is ordinarily taken for granted. If it does not evoke skepticism respecting the pieties, it is likely to be propaganda and not art. In this sense socialist realist painting, which reiterates pieties rather than undermining

5. Di Piero, *Out of Eden*, p. 145.

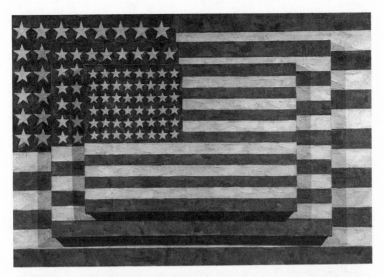

FIGURE 4. Jasper Johns, *Three Flags* (1958). Encaustic on canvas. 30⅞ × 45½ × 5 inches (78.4 cm × 115.6 cm × 12.7 cm). Collection of Whitney Museum of American Art, New York. 50th Anniversary Gift of the Gilman Foundation, Inc., The Lauder Foundation, A. Alfred Taubman, an anonymous donor, and purchase. 80.32

them, is not art even if it looks like it in form. Medieval religious sculpture and painting may seem to reassert widely held beliefs, but if they do no more than that, they, too, are propaganda. The great medieval art does express such beliefs, of course, but it presents them in a new perspective, constructing revealing notions of the place of human beings in the cosmos, the character of the Virgin, or the qualities that mark paradise or hell.

But always with some uncertainty regarding our ability to know reality. In mannerist painting, space is, in some sense, illogically organized; and the same impression of settings and spaces that are not congruent with each other or with everyday life appears in *Hamlet,* in *Don Quixote,* and in other literature of the period. That kind of handling of space is striking in Michelangelo's Sistine ceiling, where prophets and sibyls are constrained

inside a closed space, a comment on the human condition. Such contortions of space and of figures render objects and people especially memorable and hyperreal. In some instances they create spiritual depth.[6]

The art historian T. J. Clark offers an intriguing statement in that regard:

> Art seeks out the edges of things, of understanding; therefore its favorite modes are irony, negation, deadpan, the pretence of ignorance or innocence. It prefers the unfinished: the syntactically unstable, the semantically malformed. It produces and savours discrepancy in what it shows and how it shows it, since the highest wisdom is knowing that things are pictures that do not add up. . . . This is the approximate definition of modernism.[7]

These functions of art imply that it distances observers from their accustomed responses to their worlds. We feel through the mediation of works of art, but at the same time look at feeling itself from an outside perspective, recognizing its constructed quality. Consider reactions to Cervantes and his portrayal of misplaced and mistimed chivalry, its arbitrary nature, and our fascination with its effects on us. Consider the depth of feeling Edvard Munch's paintings of frightened and sick people evoke, even while he makes it evident that they reflect his own reactions rather than experience, and while he entices us into examining our sensations as we study his work. Once it is recognized, the point manifestly applies to the work of every successful artist and writer.

That is precisely the kind of response that is most dangerous for those who see it as in their interests to encourage acquiescence in the familiar ways of seeing and acting. Works of art often unsettle established meanings, encouraging the rethinking of conventional ideas and beliefs: patriotism, the effects of war, the links

6. Cf. Walter Friedlaender, *Mannerism and Anti-Mannerism in Italian Painting* (New York: Schocken Books, 1965), p. 15.

7. Clark, *The Painting of Modern Life*, p. 12.

between wealth and religion, the links between poverty and merit. Di Piero has suggested in this respect that art sometimes challenges "formulas of historical wisdom and journalistic platitudes that numb us to moral ambiguity."[8] Clearly, the political consequences of such art are potent; political language thrives on historical wisdom and journalistic platitudes.

In this light it is not surprising that the same themes recur in works of art. These are the issues that are central in shaping the minds of a culture or an era, and by the same token they are dilemmas that cannot be resolved. The creative works of the past, like those of the present, focus on them, and in doing so offer perspectives and conceptions that other works may challenge. Contending interests and ideologies are objectified, shaping postures toward them: the state as guide to the individual or as her oppressor, and the ramifications of each of these positions; the meanings of beauty; action as the consequence of rational thought or of dark forces; work as ennobling or as alienating. The list is long. Inclusion in it and interpretation of its terms and premises are uncertain.

Indeed, art has often transformed logic or denigrated it as misleading, a posture that has been especially conspicuous in some twentieth-century art, as it was in the work of some of the sixteenth-century mannerists. Salvador Dali referred to his "paranoiac-critical method," which he defined as "a spontaneous assimilation of irrational knowledge based upon the critical and systematic objectification of delirious phenomena. . . . I believe that the moment is near when by a procedure of active paranoiac thought, it will be possible . . . to systematize confusion and contribute to the total discrediting of the world of reality."[9]

While Dali was rather more inclined than most artists to dramatize his bent toward the irrational, there are certainly elements

8. Di Piero, *Out of Eden*, p. 215.

9. Quoted in William S. Rubin, *Dada, Surrealism, and Their Heritage* (New York: Museum of Modern Art, 1968), p. 109.

of this tendency in fauvism, surrealism, dada, and abstract expressionism, and in the work of such twentieth-century literary giants as Kafka and Joyce. Influential literary theory and criticism of the twentieth century reinforce this perspective, notably in the writings of Jacques Derrida and other poststructuralists, who stress the relevance of chance in constructing meanings and deride logic and other forms of "logocentrism" as rationalizations for bias, ideology, and meaninglessness. Freud's writings on art earlier in the century carried many of the same implications. And some of the compositions and poetry of John Cage reflect these assumptions as well.

In consequence, meaning, the future, reality, how to observe, and how to reach conclusions all become problematic in twentieth-century art. This phenomenon cannot be understood as a reaction to pervasive earlier rationality in art forms, of course, because the irrational has doubtless always been an indispensable theme in a great deal of art. Self-conscious attacks on rationality in recent times, however, have certainly reflected despair with the institutions of nineteenth- and twentieth-century capitalism and politics in addition to the bewilderment, anguish, fears, and hopes for survival that marked earlier forays into the irrational.

Such concepts as honor, absurdity, and lunacy come to be questioned as well as welcomed in a society in which the irrational becomes a core theme, a development that is bound to have major implications for the formulation of public policies and for responses to policies. Because causes and objectives formerly regarded as beyond the pale may now be seen—at least by some— as possibilities, a much wider range of influences on policies and public officials becomes acceptable to some, and a wider range of responses, ranging from zealous support to strong skepticism, may become evident as well. But such an evolution need not mean greater pluralism or tolerance because, on both specific issues and more general ideologies, polarization and intense adherence to particular positions can erode tolerance for minorities rather than promote it. Indeed, the ultimate examples of an explicit embrace of irrationality in recent history, the fascist states of the

twentieth century, are conspicuous examples of intolerance, both for dissident ideas and for serious art.

AMBIGUITY IN WORKS OF ART

It is risky to assign any specific meaning to a work of art because its connotations depend at least as much on the individual observer as on its textual content. Though there is likely to be a definable range of meanings that are the dominant ones for most observers, these are never definitive, for ambiguity and susceptibility to wide interpretation based on individual experience are characteristic of art. Nelson Goodman makes an observation on this point that is likely to startle anyone who has not thought about the issue:

> . . . realistic representation depends not upon imitation or illusion or information, but upon inculcation. Almost any picture may represent almost anything; that is, given picture and object there is usually a system of representation, a plan of correlation, under which the picture represents the object. . . . If representation is a matter of choice, and correctness a matter of information, realism is a matter of habit.[10]

Consider the complexities of realistic representation. In the first place the very definition of any object as "art" removes it from the world of everyday experience. To place a frame around it, literally or metaphorically, is to proclaim that it exists to be defined and interpreted. A portrait of a well-known person is no longer the person but an image that calls upon the viewer to define its connotations, which are certain to be different from other people's connotations. A public official may be a scoundrel or a hero or a reminder of one's brother-in-law or a lover or a nonentity. A discarded automobile motor, when presented as a work of art, may represent the wastes of industrial civilization, an engineering feat, an enigma, or an artist's witticism. René Magritte forcefully called attention to this property of art in his famous painting *This Is Not*

10. Goodman, *Languages of Art*, p. 38.

a Pipe. At the same time, innovative examples of realism (*The Red and the Black; Go Tell It on the Mountain*) raise questions about conventional portrayals.

Figurative art, then, is hardly less ambiguous than abstract art, which more explicitly calls upon the spectator to supply its meaning. The former simply begins its challenge to the mind of the observer at a different place. How that challenge translates into meaning is the great mystery that art presents. That process seems unfathomable, though its profound consequences are apparent, for, as already suggested, they create and transform "reality."

Art that purports to be realistic is likely, moreover, to be blatantly ideological, because the seeming realism is always a construction of the dominant ideological currents influencing the observer; it cannot be a mirror of an objective, universally recognized reality. That it *seems* to be such a mirror strengthens its potency as ideology.

Images and symbols are the prerequisites for reasoning and play with concepts, and so the political process becomes a parade of symbols and images, which in turn becomes the basis for diverse reactions to public issues and public figures. At no stage of this process is there any kind of fixed or consensual representation; instead, there is inculcation and divergent responsiveness to the symbolism.

Arbitrariness in perception and conception is especially prevalent in political affairs. Politics is a spectacle reported to the public from a remote arena. Few are participants, and even those few interpret the political world in terms of disseminated images. Because conflicting interests, ideologies, and philosophies are at stake and the stakes can be high, there are always contending versions. Contention and ambiguity feed each other. Advocates of political movements constantly challenge other interested groups regarding all the key questions: the causes of favorable and unfavorable developments; the consequences of proposed courses of action; what alternative policies would have been better; which individuals bear responsibility; the short-run and long-run outlooks; who the heroes, victims, and villains are. Because the issues

are typically complex, the facts always subject to interpretation, and some facts likely to remain unknown, and because diverse groups are committed to conflicting ideologies, these questions can never be resolved to everyone's satisfaction. Their function, rather, is to remain in contention so that the uncommitted can be induced to see the issues in the way that will benefit particular advocates. In short, political maneuvering, success, and failure hinge on transformations in conception and perception, which occur selectively.

At any historical period the most widely promulgated and accepted perceptions reflect and reinforce the dominant social relationships. Base and superstructure complement one another, but their links are never rigid outside the fancies of vulgar Marxists. Material conditions and striking events render people susceptible to new ways of building reality, but artists must provide the categories, the premises, the modes of seeing, and the cognitive pathways.

Changes in cultural creations may fail to follow changes in economic and social conditions; or works of art may bring new ways of seeing and understanding either existing or altered conditions. So art lays the basis for the developments we conventionally see as political: voting, lobbying, participating; supporting, obstructing, or ignoring political causes.

The force of this phenomenon is potent for a reason that is not self-evident or even commonsensical. While art that refers to political issues and personalities seems on its face to be simply one more way to represent these entities, it is really doing something quite different. It is creating a new reality, a semblance apart from everyday life, that becomes compelling for those who make themselves susceptible to it. It is neither description nor representation, but a powerful influence toward visualizing issues and people in a particular way for reasons that need have no source at all in everyday life, though the art then shapes the meaning of everyday life. *Richard III,* together with other works of art that construct our image of tyranny and evil, becomes a model into which we fit our ideas about contemporary and past tyrants. Degas creates a world

of the professional dance, its romance and its prosaic side as well. Art shapes the meaning both of common experiences and of empirical research, and it does so compellingly.

Art expresses an ambiguity that provokes, not an explicitness that terminates wonder and analysis. Its pervasiveness in shaping thought and feeling accordingly yields an indeterminacy in action and belief that characterizes the human condition, but that a great deal of writing and discourse is designed to obliterate. The more explicit the political message of art, the less influential it is likely to be, for explicit depictions are less able to incite and excite; they either evoke greater resistance or simply objectify conventional beliefs.

Leon Golub's paintings are instructive about the link of art to moral ambiguity. In *White Squad I* (fig. 5) and other works, he has painted human fiends whose actions are deeply disturbing; but at the same time and with the same forms, Golub evokes a measure of empathy with these monsters while also exciting the viewer's shame at experiencing this attraction to them.[11] In such creations, complexity amplifies ambiguity while conveying contradictory political messages.

Many works of art that depict familiar scenes and objects stimulate the viewer or reader to project his own image and interpretation of them, and sometimes to recognize the arbitrariness of the projection. Such recognition also becomes appreciation of the ambiguity in banal objects, presumably including political statements, claims, and promises, which are especially likely to be vapid and predictable. But it may also encourage recognition of everyday objects as art when they are presented as entities to be observed and analyzed.

Works of art, like language, derive their import, then, from the metaphors they suggest to observers. Lear's relations to his daughters would be of little interest if audiences did not see his ties with the older daughters as emblematic of ungrateful children generally, and his relation to Cordelia as a metaphor for parents' sus-

11. Cf. the discussion in Di Piero, *Out of Eden,* p. 172.

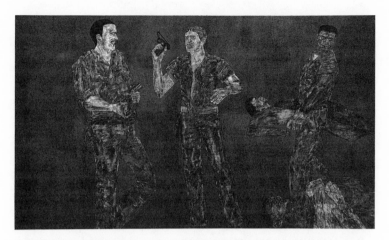

FIGURE 5. Leon Golub, *White Squad I* (1982), synthetic polymer on canvas, 120 × 184 in. Collection of Whitney Museum of Art, Gift of the Eli Broad Family Foundation and purchase, with funds from the Painting and Sculpture Committee, 94.67. Photograph: courtesy Ronald Feldman Fine Arts, New York. Used by permission of the artist.

ceptibility to misinterpretation of their children's behavior. The Mona Lisa stands, among other things, for the enigma all women present. These, at least, may be the most common meanings of these creations, though they are susceptible of an infinite range of other meanings as well. Abstract expressionist paintings condense whatever conceptions, perceptions, fears, enthusiasms, or confusions a viewer reads into them. Each work of art, then, objectifies or universalizes emotional or physical experiences, and in doing so acquires a connotation that influences future thought and behavior.

That such metaphoric projections are largely unconscious makes them more potent,[12] for there is then no recognition of the importance of examining them skeptically. Awareness of the varied or contradictory possible meanings of art, by contrast, not only can engender skepticism, but is often likely to generate adherence to a particular perspective, at least for a time: an adherence that may become ritualized rather than adopted from observation or logic.

12. See Mark Johnson, *The Body in the Mind* (Chicago: University of Chicago Press, 1987), pp. 82–83.

ART AS CHALLENGE TO THE POLITICAL PIETIES

At different levels of abstraction, works of art convey disparate perceptions, a phenomenon that twentieth-century art makes especially evident.[13] Both surrealist and cubist art call attention to important truths about multilevel meanings. So do the writings of Kafka, and so does Joyce's later work. These creations and many others remind us as well that Cartesian dualism does not work: that audiences cannot be separate from the works they see or hear, but rather are shaped by them, just as they in turn influence the meanings of whatever impinges on the senses; that the subjective and the objective help form each other.

For everyone who comes to recognize these truths, which in some measure transcend common sense, the world of everyday life, including the political world, becomes a different, more complicated, more fluid and enigmatic place. Politics now has to be seen as multivocal and manipulable. The meaning of every action, claim, promise, and threat is contingent on its level of abstraction, the plans of the actor or speaker, and the audience's aspirations, anxieties, and fears, themselves at least partly learned from works of art. A public official's hostile statement about another country may be interpreted as a play for votes, a threat of war, an effort to present herself as tough, a ploy to win favor with particular countries, the nonthreatening reflection of an embittered personality, or one of many other possibilities. Metamorphosis becomes the norm. In this way art reveals a great deal that is fundamental about political life.

As changes in posture and in meaning progress, rationalizations both for the changes and for diverse interpretations of them become necessary. While rationalizations for particular art forms are typically less influential than the implications of the works themselves, political maneuvering relies heavily on rationalizations. Their ratio to actions is high, even though their influence is typically weakened by suspicion that they are insincere or misleading.

13. For many examples from art history, see Gombrich, *Art and Illusion.*

With the growth, in the twentieth century, of audiences that are easily reached by electronic media, political tactics and statements have increasingly become parodies of themselves as they focus on public-relations tricks and subterfuges rather than the substance of public issues. A professional vocation has developed that devotes itself to diverting attention from actions and events that might help a political opponent; to publicizing events that are created only to be publicized; to putting forward deceptive claims and television pictures; to appearances on "talk shows" that encourage zealotry respecting issues that have little to do with well-being for most of the population; and even to winning support by publicizing clever public relations ploys as though these were signs of effective government.[14]

As politics becomes a caricature of rational communication and debate, art that is a commentary on politics, as in some sense virtually all art is bound to be, has to become more unorthodox to win attention and have an effect. The succession of unconventional styles of painting in the twentieth century, from fauvism at the start of the century to pop art near its close, and the progression in literature from Kafka to Burroughs to rap lyrics, are clearly political statements growing out of this milieu, whatever else they may be. Both the painting and the literary productions, then, promote and reflect the pessimism, uncertainty, alienation, despair for the future, and instability in the present that mark the political spirit of this century. They must be assessed as part of the same configuration in order to be understood at all.

All the more so because the very production and existence of serious art encourages skepticism toward the pieties of regimes, elites, and the respectable. These groups are likely to be optimistic, content with current conditions, closely tied to social institutions, and loyal to them. What they put forth as traditional, wise, moral, or self-evident is likely to reinforce the ideology that

14. For an astute examination of these and similar developments, see Kathleen Hall Jamieson, *Dirty Politics: Deception, Distraction, and Democracy* (New York: Oxford University Press, 1992).

serves their interests. Art is often ironic respecting these groups and institutions; it readily challenges platitudes and questions moral ambiguity. In any case it visibly constructs realities and so demonstrates how easily that can be done, raising doubts that orthodox interpretations of the social world should be regarded as the only valid ones.

Indeed, works of art frequently suggest, usually subtly, that the conventional or readily grasped version of social and political reality is a potent aid to intimidation, or to propaganda, or to a self-serving construction. This theme is central to most novels of social criticism, as it is to such Shakespearean tragedies as *Hamlet, Macbeth,* and *King Lear* and to many of the Greek tragedies. It radiates as well from some paintings, including the surrealist paintings that focus on social entities, and from virtually all successful political cartoons. Without freedom from the control of the socially and politically powerful it is not possible to create art. Art is therefore always potentially subversive, so that it is understandable and in a sense "rational" for governments to become suspicious of art and artists, as they always are.[15]

THE HUMAN SUBJECT:
AGENT, PAWN, OR CONSTRUCTION?

The treatment in works of art of the human form—its contours, its beauty or ugliness, its place in the cosmological or social scene—has both reflected and encouraged widely divergent perspectives on the appropriate treatment of human beings.

Idealization of the human form is recurrent, though the ideal people portrayed in paintings and literature are likely to be a small set that for one or another reason is regarded as an elite. The idealization also conveys the message that the people portrayed are constructed models rather than human beings. It can be based on saintliness, prowess in some difficult form of action, physical beauty, or any other ideal. Depicted figures can therefore be idealized in some respects and not in others.

15. See pp. 42–44.

The most conspicuous idealizations in the political realm are those of dead civilian or military heroes, who come to stand for some characteristic that a powerful group or class wishes to promote in the contemporary citizenry. So portraits of Washington and Lincoln, stories about them, and some biographies and hagiographies use the dead to mold the living. Evil people as ideal types serve the same purpose: they offer models of lives and behavior to be avoided for fear of losing one's soul as well as control over one's body.

The more fundamental issue on which art influences belief concerns the role of the subject in social action. Are human subjects independent initiators of social movements and actions? Are they pawns moved by economic conditions and the social structure? Or does social action hinge on some kind of interaction between social structure and human agency?

This is, of course, a classic controversy both in social science and in everyday discourse, which probably means that it depends on ideological judgments impossible to verify or falsify. The issue here is not how it should be resolved, but rather how works of art influence beliefs about it.

The strongest and most common influence probably comes from emphasizing human agency, and specifically from creating heroes and villains. Stories for children are most obvious in this respect, and their debatable lessons about the good guys and the bad guys doubtless last throughout life. That focus has also been the most common one in adult literature and in all other art forms as well, from the Bible to paintings, narratives, and poems depicting heroic actions, and in other stories and paintings that portray horrors, such as *The Rape of Lucrece*.

These constructions in art draw their appeal from the gratification that comes from allocating praise and blame, an emotion that is ubiquitous in political action. The focus on agency offers that satisfaction and also provides a ready and facile explanation, while an emphasis on social structure does neither. Little wonder that artists have concentrated chiefly on agents.

More sophisticated works of art take account of both possi-

bilities, even while usually accentuating agency. Although they typically focus on subjects with particular talents and character flaws, they analyze the influence on individual lives and character of environments, hierarchies based on class and other factors, and social conditions.

Oedipus sins, but the tragic nature of the play stems from his ignorance of the facts that allowed him to sin. The characters in *War and Peace* display a wide range of personal traits, abilities, and deficiencies that bring them many forms of success, happiness, failure, and sorrow; but Tolstoy makes it clear repeatedly and explicitly that they are in a larger sense pawns of the times and the conditions in which they live. Virtually every great tragedy offers the same lesson, and many comedies do so as well, as do many paintings and dances. The role of the subject emerges both as critical and as at least partly predetermined. It is vital to the dramaturgy of these works, even though it is secondary from a longer and larger perspective. In any event, the emphasis on agency in works of art has implications for politics that are critical and often overwhelming. It encourages a narrow perspective, while discouraging attention to major influences on action and outcomes.

In some important twentieth-century art, however, agency fades and is replaced by chance at least as often as by social structure. In the two writers who were arguably the greatest of the century, Joyce and Kafka, both of whom wrote in its early decades, the characters are not in control of their destinies, and it is unclear what, if anything, *is* in control, except luck and accident. Experience becomes absurd. Beckett later carried that emphasis much farther; its power to disturb in his works arises in large part from its plausibility. Chance also became a leading influence on painting—first in surrealism; later, more explicitly, in abstract expressionism and in the work of Johns and Rauschenberg—while Segal's sculptures offer a kind of hypernaturalism, which lends itself to the same kind of questioning. Resort to chance has been influential as well in some dance choreography, some poetry, and a great deal of popular music.

Early in the twentieth century, abstract painting foreshadowed

the elimination of subject and object as well as the free and continuing associations, floating signifiers, and epistemological breaks that were explicitly analyzed in the philosophy of the latter part of the century. For some artists this note was self-conscious. In 1938 Wassily Kandinsky wrote in a letter to Herbert Read: "J'ai pensé alors que j'était le seul et le premier artiste qui avait le 'courage' de rejeter non seulement le 'sujet,' mais même chaque 'objet' dehors de la peinture."[16] While Kandinsky was doubtless exceptionally insightful about the importance of this move, his claim to be the first and only artist to reject not only the "subject" but even every "object" outside the painting is hardly convincing.

Poststructuralism, the leading literary theory of the latter part of the century, offered an explanation and a rationale for the emphasis on chance and luck, a focus that had been anticipated in considerable measure in the linguistic theory of Ferdinand de Saussure, published at the time of the First World War. Saussure suggested that "the arbitrariness of the sign" and "difference" are cardinal sources of meaning.[17] Derrida and other poststructuralists later carried this theme considerably further. They deplored the prominence in Western philosophy since Plato of logic, the Deity, and other systematic influences as explanations of meaning, and pointed instead to chance associations, coincidental differences, and the disposition of writing to undermine its own logic (deconstruct).[18]

This emphasis in the arts and in some prominent philosophical works of the twentieth century certainly reflects, at least in part, the sequence of tragic and harrowing political events of the century, as well as developments in the sciences and mathematics that called attention to inherent uncertainties and the limits of reason. It marks an epistemological break with the nineteenth century's focus on positivist science and progress.

16. Quoted in Read, *Art and Alienation*, p. 141.
17. Ferdinand de Saussure, *Course in General Linguistics* (London: Peter Owen, 1960).
18. See especially Jacques Derrida, *Of Grammatology* (Baltimore: Johns Hopkins University Press, 1976).

So far as the implications of this development for politics are concerned, its chief concomitants would appear to be widespread and often deep skepticism regarding political institutions and the role of individual leaders in shaping them; little confidence that they promote the public welfare; and increased zeal to pursue perceived self-interests through such means as ethnic, racial, and religious rivalry and violence. The contrast between the major movements in the arts in the nineteenth and twentieth centuries was as profound as was the contrast between the two centuries in wars, genocides, ethnic violence, and confidence in governmental institutions. These contrasts, moreover, have certainly been linked to one another.

In a limited sense that transformation can be understood as a recurrent cycle that moves between art that accepts, idealizes, or romanticizes the world, often constructing it from a perspective outside the thinking and feeling of real human beings, and an art that reflects anguish, disgust, pride, or concern respecting human life and action. The contrast does not fit neatly with historical periods, of course, but in a more basic sense points to alternative stances toward life that can coexist temporally and also in individual human beings, though one or the other posture is usually dominant. Mannerist painting and literature incorporated both these modes, though the second predominated, especially in works like those of El Greco, Cervantes, and Shakespeare. And twentieth-century art exhibits the skeptical and critical mode even more distinctly and pervasively: notably in writers like Kafka and the Jewish novelists of the second half of the century and, in the graphic arts, in fauvism, cubism, dadaism, expressionism, and surrealism. In many cases there is an explicit rejection of coherence and continuity, mirroring and reinforcing recognition of their frequent absence in politics and government as well. The twentieth-century human being lives in a world marked by skepticism and suspicion regarding social and political institutions and her own future prospects. Art has been pivotal in objectifying and deepening that outlook.

Architecture, Spaces, and Social Order

That a man meets with his aides in the Oval Office of the White House reminds him and them and the public to whom the meeting is reported of his status and authority as President, just as it exalts the status of the aides and defines the general public as nonparticipants who never enter the office. Even the person who cleans the Oval Office gains some status from the setting of her work. The prisoner in a solitary confinement cell and the mathematician in an austere office may occupy somewhat similar rooms, but the setting constricts the dignity and autonomy of the one as potently as it helps establish the dignity and autonomy of the other. Settings subtly but powerfully evoke authority, dignity, independence, competence, creativity, and the opposites of all of these qualities.

Why do actors and actions need settings to complete such definitions, and just how do spaces fit into the transaction that accomplishes it? Consider a general explanation and then some specific links among settings, actions, and power. Occupations, education, income level, titles, and achievements directly influence individual power and status and the role structures within which individuals act, but such signals are always blurred. Often the cues conflict. The poor are seen both as lazy or incompetent and as victims of unfair institutions or bad luck. The wealthy are seen both as industrious and proficient and as parasites. A political prisoner is usually a hero to many and more degraded than a thief or murderer to many others. Such ambiguity and ambivalence regarding what is expected of people and their place in the social order are bound to generate anxiety. Elites feel concern about the continuation and justification of their privileges. The disadvantaged feel unsure that their deprivations are necessary or deserved, but also feel some attachment to the regime and the polity that imposes the deprivations.

The mind is a sensitive organism, readily reflecting a wide range of perceptions and beliefs, even when they are logically incompatible, as is evident from the range of cognitions regarding social issues that every individual experiences as he or she reacts to information and moves among different social situations. Consciously and unconsciously, people play with cognitions, rearrange them, and try out patterns of meaning to make them fit ambiguous and incomplete information. But concurrently with that skeptical and playful intellectual activity, people adapt to their social situations, often curtailing play with information and possibilities. Such adaptation may mean reinforcement in one another of a small set of beliefs that rationalize inequalities, social classes, and social roles: beliefs that justify established privileges and deprivations that cannot easily be changed, replacing free exploration of the social world with fixed, intense beliefs.

Symbols that condense a wide range of individual fears, hopes, and cognitions into a focus on a narrow set of socially reinforced perceptions help resolve such anxiety. For such condensation symbolism to gain its hold on people's minds it seems necessary to objectify beliefs in some entity, visible or imagined, that has no semantic content in itself, so that its meaning must come from whatever people want to believe and read into it.[1] In politics such terms as *divine will, the public interest, communism, democracy,* and *justice* serve that symbolic purpose, but so do widely known buildings, spaces, and public figures that are accepted as objectifying some aspect of the polity or the social order. It is as if beliefs that are undemonstrable and doubtful have to be objectified in an entity or concept that then confronts people as reality, repressing the tentativeness and the search for validation that are otherwise characteristic of the play of the human mind.

Like the linguistic terms that serve as symbols, spaces can therefore take on quite disparate meanings for different people and for diverse social situations. The space itself does not convey meaning

1. Among the major contributors to this view have been Sigmund Freud, Edward Sapir, Suzanne Langer, George Herbert Mead, and Harold Lasswell.

as if it were a simple code. It serves, rather, as an objectification of whatever shared meaning a particular group of people need to reinforce in each other, so that the meanings for groups with conflicting interests are frequently dialectical, as illustrated below. The space or structure constitutes one part of a transaction whose other component is people who "take the role of the other" and thereby evoke common meanings in one another.[2]

Observations often generate anxiety about controversial issues; but public spaces symbolize widely held beliefs that are clear because they reflect psychological needs, not observations of the world. Conspicuous public buildings catalyze the common search for clarity, order, and predictability in a threatening world. For most Americans the Oval Office symbolizes the power of the presidency and its reflection of the public will, and therefore suppresses awareness of divisive opposition to the incumbent, distrust of the institution, or ambivalence about both. Acts must take place in settings. When the acts reflect ambivalence and social strain, as controversial political actions do, the settings help to reestablish clarity. That is their symbolic contribution. That evocation reinforces established inequalities by reassuring both the advantaged and the disadvantaged that the social order of which they are a part is sanctioned by whatever grand symbols are currently accepted: divine will, the public will, reason, merit, or science.

Another characteristic of publicized spaces strengthens their connotation of continuity amid flux, and therefore of order amid uncertainty. The spaces in which key decisions are formalized and key commitments made affect the well-being of many people. The most publicized and cherished buildings, notably government or religious buildings, become significant symbols that remind everyone whose attention they command that they share a common heritage and a common future, though it is a reconstructed past and a problematic future that rationalize current institutions. It is true that some will not accept this meaning, or accept it so ambiv-

2. This formulation is obviously taken from the work of George Herbert Mead. See his *Mind, Self, and Society.*

alently as to make it meaningless. German Jews under the Third Reich doubtless saw the Reichschancellery, the Sportspalast, and the Nuremberg Amphitheater as symbols of evil and repression rather than of Aryan supremacy and German nationhood. But that is another way of saying that the bonds of those Jews with the regime had been severed or weakened to the point of meaningless-ness.[3] Symbols of unification can function only where there is a bond to reinforce.

ARCHITECTURAL EVOCATIONS

Public spaces contribute to social integration generally, but do so by strengthening particular connotations of specific spaces. Each such space evokes a number of different meanings, but with the striking characteristic that the meanings of a structure for differ-ent people and for different situations complement one another so as to reinforce established inequalities.

Consider some kinds of public spaces that are especially potent as social and political symbols. It is the monumentality of great public buildings and some corporate office buildings that most conspicuously distinguishes them from the rest of the environ-ment. The scale of the structure reminds the mass of political spec-tators that they enter the precincts of power as clients or as sup-plicants, susceptible to arbitrary rebuffs and favors, and that they are subject to remote authorities they only dimly know or under-stand. And the same monumentality carries a reciprocal meaning for the functionaries who enter these buildings regularly to exer-cise authority. For them, the grand scale of the setting in which they make decisions emphasizes their power and their distinction as a class from those who are subject to their decisions. Such spaces legitimate the power of elites and of officials in exactly the same way that they highlight the vulnerability of non-elites, though there is also likely to be some recognition by each group of the beliefs and responses of the other. These meanings of public

3. For an enlightening account of Nazi symbolism see Mosse, *The National-ization of the Masses.*

spaces are not formally taught. They operate powerfully but sub-consciously, though they are readily recognizable once they are brought to attention.

Just as spaces hold nonobvious dialectical meanings for elites and non-elites that perpetuate domination and submission, so this practical effect of architectural symbolism is rationalized by still another dialectical meaning that is purely symbolic and so *is* deliberately disseminated. People are taught to see legislative halls, courtrooms, executive mansions, and even administrative offices as symbols of government by the people and equality before the law; as the places in which public servants carry out the public will, where luck and arbitrary power play as little part as possible. These reassuring meanings coexist with those that evoke domination and inequality in everyday life. Everyone recognizes both of them and at different cognitive levels believes both. The result of such dialectical realities is, in Kenneth Burke's insightful comment about political rhetoric, to "sharpen up the pointless and blunt the too sharply pointed." [4]

The experience of inequality, of rebuff, and of arbitrary power becomes easier to accept and to rationalize because the symbolism of democracy and of equal protection is potent. For elites the symbolism justifies continuing and expanding their privileges in money, status, and power. For both groups, spaces as symbols minimize the anxieties arising from the ambiguities and conflicting clues of everyday life. Logical inconsistency is no bar to psychological compatibility because the symbolic meanings both soothe the consciences of the elites and help non-elites to adapt readily to conditions they have no capacity to reject or to change.

Although spaces, like other politically meaningful symbols, help reconcile other kinds of tensions as well, those based on social class and economic inequalities are usually paramount. The availability in the culture of contradictory meanings enables both the privileged and the disadvantaged to accept and to rationalize their

4. Kenneth Burke, *A Grammar of Motives* (New York: Prentice-Hall, 1945), p. 393.

situations. In this way dominant symbols win mass support for the values of the groups that are already powerful, economically and in political influence; and they do it at least partly by creating a problematic impression that those values already command popular support. Here is a classic instance of conflicting beliefs that create a consequential synthesis.

CONFLICTING BELIEFS

Specific architectural features of public and private buildings legitimate class distinctions in more direct ways. There is a consistent contrast among governmental offices according to the socioeconomic status of the clients who come regularly to transact business in them. The business people, lawyers, and interest group representatives who negotiate contracts, arrange for government subsidies, or bargain about administrative rules and the disposition of administrative proceedings do so for the most part in well-appointed, comfortable, sometimes lavish offices and conference rooms: spaces appropriate to the high stakes and handsome benefits that are involved. The settings are major contributors to the definition of such proceedings as the responsible implementation of the law by experts and professionals, though critics may see some of these transactions as the problematic use of public funds to subsidize those who already wield an undue share of money, status, and influence. Clients in these settings are not defined as getting "help" from government, but they win lucrative benefits from public contracts, arms sales, favorable tax rulings, and other administrative actions.

Another class of clients, exemplified by welfare applicants, emotionally disturbed people, and public school students, is explicitly defined as in need of "help"—and, by comparison, gets very little of it. The settings in which they deal with officials define the worth of the clients as eloquently as do the bureaucratic offices discussed above, but in the opposite way. Waiting rooms are typically crowded and often drab and uncomfortable. The physical arrangements reflect the dependency of the client on the power

and goodwill of the authority. To wait an indefinite time for a benefit that may be denied and is certain to be small acclimates the applicant to her or his vulnerability and powerlessness. In both of these contrasting cases, the setting that is appropriate to the act taking place in it is important politically because it helps to define the client as worthy or as suspect in the eyes of the general public. Though that public may rarely or never see either kind of office, it knows the setting, which establishes the appropriate view of the client and of the public policy by showing everyone what the generalized expectation is. In this sense it is the general impression of the scene that is symbolically and politically critical, even if that impression is invalid in particular instances.

Private buildings as well as public ones serve this function, probably in a less subtle way. That the size, luxuriousness, or decrepit condition of a house or an office defines the worth of its inhabitants in both senses of the word *worth* is taken for granted, and the definitions of the self and of the other evoked in this way help make the connotation a self-fulfilling prophecy. In this case the effect is so commonly recognized that many people are tempted to buy houses and cars they cannot afford in order to create a more generous public definition of themselves.

Not only the individual structure, but also its neighborhood, serves as a constant reminder to the inhabitants and to others that they are worthy or unworthy. Though the effect is not consciously planned, the decaying neighborhoods, peeling paint, and shabby and crowded rooms that form the daily settings of the poor are likely to contribute to low self-esteem, defeatism, and low aspiration levels, and therefore to docility and order. The inequalities of the social structure reproduce themselves in substructures and perpetuate themselves through their psychological consequences. By the same token, zoning laws that protect the affluent from airport noise pollution and factory air pollution but systematically expose the poor to these blights are not consciously intended to perpetuate inequalities in income and in power or to induce acceptance of deprivation, though these may well be more consistent

consequences of zoning than its ostensible justifications, such as health protection, which is highly selective in its incidence. Manifestly, the extent of availability of finances to create structures and spaces that define status and well-being is critical.

The expressive meanings of spaces therefore perpetuate order, and do so in conjunction with their evocation of a wide range of specific roles and self-conceptions. Particular features of buildings enhance and legitimate differences among individuals. The artist's studio, the writer's study, the professor's office, and the monk's cell are places in which the inhabitant's autonomy, creativity, or spirituality are expected to show themselves. The occupancy of such a space, though that space may be sparse, reaffirms this expectation for the occupant and for others. Another sparse room, the "quiet room" in a mental hospital, reinforces the opposite definition of its occupant: the person whose autonomy is denied and whose behavior must be controlled. Yet even in this instance the space catalyzes whatever evocation is socially reinforced. Among intellectuals, one major evocation of prisons is that a great deal of original and moving writing and painting has taken place in them: Antonio Gramsci was joining an illustrious company when he wrote an important book in prison.

The physical characteristics of a space manifestly do not constitute a code with a single meaning if physically similar spaces can convey different, even diametrically opposed, meanings. The point is, rather, that a typified space comes to stand for, and to reinforce, generalized expectations about its occupants' roles. Such generalized expectations do not take account of empirical observations suggesting that they should not reasonably apply, for example, to particular artists or professors or mental patients because they have been inappropriately labeled or are the victims of prejudice or the beneficiaries of favor or of luck. Spaces affirm the established social roles by encouraging those who act and those who look on to respond to socially sanctioned cues and to ignore incompatible empirical ones. Spaces reaffirm a dialectic of hierarchical distinctions.

Work spaces in bureaucratic settings illustrate a similar point.

Interior spaces can be constant reminders to workers and to on-lookers of hierarchical distinctions: who wields authority to reward or punish, who is competent and independent, and who, by contrast, is under surveillance, in need of regulation to avoid nonconformity or incompetence. Architectural features create fine distinctions in these respects through signs everyone learns to recognize: the desk surface free of papers, symbolizing delegation of work to subordinates, or the cluttered desk, symbolizing assignments that cannot be evaded or passed on; offices of different sizes, with or without various embellishments; a cubicle office with walls that do not reach the ceiling; a workplace in a large newsroom, typing pool, or industrial loft; a bed in a barracks or a psychiatric dormitory or a prison, with nurses or guards able to bug conversations or exercise covert surveillance through closed-circuit television.

It is, of course, the architectural *contrasts* that exalt or degrade occupants in such hierarchical settings. That mental patients in the sophisticated modern ward can be seen or heard without their knowledge defines the head nurse as omnipresent and all-knowing by the same token that it infantilizes the inmate as irrational and in need of close surveillance. And though the nurse may be less intelligent or less competent than the inmate, or deluded by psychiatric mislabeling of the inmate's problem, the space as symbol encourages them both to act out the generalized expectation, not the one that fits their actual competencies.[5] More than that, self-conceptions established by such symbols become self-fulfilling prophecies if not countered by conflicting cues. People become the executives, the authorities, the psychotics, or the unreliable employees their settings tell them they are. Research in several kinds of highly structured milieus reaches that depressing conclusion.[6]

Yet while bureaucratic spaces help perpetuate the established order, government and business office buildings concurrently symbol-

5. Cf. Murray Edelman, *Political Language* (New York: Academic Press, 1977), chap. 4.
6. Ibid., pp. 82–85.

ize service to the people, responsiveness to change and to the public will, and other reassuring attributes that permit the privileged and the disadvantaged to live with their respective situations.

DIVERSE MEANINGS FOR PARTICIPANTS AND FOR SPECTATORS

Examples already cited suggest that the same space or structure can hold disparate connotations for people in different situations, but with each meaning likely to be strongly espoused. One of the more telling divergences of this kind concerns occupancy of a space, as distinct from looking at it or hearing about it. As a condition for exercising power, seeking a benefit, or being treated or disciplined, occupants are expected to play a particular role and are sanctioned if they fail to do so. Their conduct and feelings about it may have only incidental bearing on what the space means to the general public, whose feelings of awe, dread, reassurance, or something else are socially evoked, as noted earlier. Though the connotations are different, they typically help construct and reinforce each other—still another instance of a dialectical relationship that evokes a synthesis.

Spaces are especially powerful symbols when they convey meanings tacitly rather than explicitly. The Supreme Court building symbolizes justice explicitly, and so there is some incentive to question the validity of the symbol when a particular court decision seems unfair; but the difference in status symbolized by the crowded waiting room for welfare applicants and the plush office of the top administrator makes its point less explicitly, more subtly, and therefore more compellingly. Consciousness of a dubious link is an incentive for skepticism.

ARCHITECTURAL EXPRESSION OF SOCIAL BELIEFS AND RELATIONSHIPS

Architectural cues that are potent because they function subconsciously reaffirm many other kinds of social relationships as well, and so help insure the social fabric against tearing and against

drastic change. Especially subtle, powerful, and common are buildings that reinforce a belief that people's ties to a heroic past or a promising future are their important identities: that the immediate effects of their actions are trivial compared to their historic mission. The monumentality already mentioned serves this purpose, as does governmental, church, and business architecture in anachronistic styles: Roman, Greek, Gothic, or the "modernistic" buildings that reflect a typification of a future based on science fiction. The most unfeeling rebuffs, debasement, and destruction of flesh-and-blood human beings have come from those whose vision and passions were fixed on the good they would do in a problematic future, so that they could resolutely destroy people in order to save mankind. The fifteenth-century Spanish Inquisitor, the contemporary lobotomist, and the Nazi heralds of the Thousand Year Reich are examples of this recurring form of political perception, and they all had impressive architectural symbols that reminded them of their special grace as saviors.

It is usually the topical associations of whatever takes place within a structure that contribute its symbolic connotations, but occasionally a structure is designed so that its physical properties will convey an intended meaning. Cathedrals and churches built in the shape of a cross are a familiar example. In the Holocaust Memorial Museum in Washington, visitors enter the exhibits at the top of the building, and as they descend, corridors and catwalks become progressively narrower, suggesting the increasing constrictions on Jews in the Nazi era.

But such instances of structures with specifically intended meanings are not likely to maintain them for all onlookers. For non-Christians the symbol of the cross can be a reminder of persecutions their ancestors suffered as heretics. For anti-Semites the Holocaust Museum is another instance of inappropriate Jewish influence; perhaps it reinforces a belief as well that the Holocaust never took place. At the same time, such symbolic conflicts strengthen the intensity of the architectural symbol for each contending group.

As just noted, symbolic connotations intended by the architect are sometimes the meanings the audience recognizes and sometimes are not. But the response a space evokes, rather than the architect's intentions, is always critical. When responses diverge radically from whatever the architect intended, as they often must, the responses, not the intentions, determine meanings.

Social controversy and ambivalence about public policies are reflected architecturally in revealing ways. The governmental bureaus that evoke both the strongest anxieties and the most powerful reassurances, Defense and the FBI, are housed in especially massive buildings that have become conspicuous symbols of the fears that war, crime, and subversion evoke. The Pentagon and the J. Edgar Hoover building seem designed to avoid any suggestion of ties to a past, real or mythical, and to emphasize bulk, labyrinths closed to the citizen, and awesome power. They evoke concerns that reflect differences in ideology and heighten ambivalence. It is as if the assertion of patriotism, nationalism, and national security through the volume and obtrusiveness of the structures is a rebuke to that part of the population which sees the defense department and the FBI as possible threats to life, to peace, or to liberty. By the same token it is a rebuff to whatever qualms the supporters of these agencies may feel about their functions. This architecture reflects a distinctive subculture and a divisive ambiance, though its meanings are dialectical, as usual. The classic and graceful forms of the Capitol and the Supreme Court building, by contrast, suggest a common heritage that helps to unite Americans whose class and group interests may diverge.

DIVISIVE INFLUENCES

The theme of unity or divisiveness is a common motif in the symbolism of public spaces. It is a politically crucial theme because divisions are constantly mitigated and mystified both by symbols of unity and by social schisms that crosscut the oppositions based on class or ideology. Probably the most powerful kind of divisive influence that spaces can exercise is to define those outside them as alien, dangerous, subhuman, or superhuman. Some examples

already mentioned do this. The FBI hierarchy apparently defined members of the Socialist Workers Party, antiwar demonstrators, and Martin Luther King, Jr., as dangerous and alien to America and therefore deserving of harassment and repression.

The very existence of a space symbolizing norms that some see as threatening or divisive reifies, strengthens, and perpetuates the norms. Certain spatial and physical arrangements markedly intensify this kind of effect without making people conscious that they are doing so. Such arrangements typically present themselves as technological aids, and their focus on technique blurs awareness of the constrictive assumptions about values that they promote.

The key spatial characteristic that achieves this effect appears to be the consignment of a class of people to a space that does not intermesh with one's own so that they are no longer perceived as significant others. They are no longer people from whose perspective one assesses one's own contemplated actions.

Modern bureaucratic technology makes such consignment to an alien space easy and unobtrusive, and defines it as rationality in the sense that it is justified as a means to accomplish a widely shared objective. In terms of physical space its most common manifestation is the embodiment of a class of people as dossiers, file cards, or markers on a map. The filing cabinet or computer memory becomes the appropriate setting such entities occupy, and their lives as files reaffirm their definition as objects with particular characteristics rather than as complete human beings. What is important about such an entity is a skill, a pathology, a criminal record, a physical shape that can lift weights or compete in a beauty contest, membership in a suspect organization, an age range, or a skin color. Decisions can be made, preferably quantitatively, that such people can be used, abused, favored, or repressed without distracting knowledge of their human ties or their talents or disabilities, and above all without empathy. Efficiency criteria rationalize the procedure, but it is made psychologically possible by the manipulation of spaces so as to convert human beings into predefined characteristics that have no bearing on their humanity. The result is alienating and therefore socially divisive.

Perhaps the ultimate form of this characteristic modern phenomenon, both as the use of space to constrict perception and as alienation of some people from others, occurs in the "war rooms" and operations planning rooms of military bureaucracies. If others are dots on a map in a context that highlights their aggressive potentialities, they *become* those aggressive characteristics, and it is easy to plot preemptive strikes or chemical warfare against them, even while, in a radically different setting a few blocks away, it is just as easy to plan the exchange of artists, ballet companies, and symphony orchestras with the potential bombing targets.

The effect of riding in automobiles on the perception of pedestrians, bicyclists, and other motorists demonstrates that spaces can banish people to an alien universe even when those others are physically close by. People who are usually good-natured and gregarious are often likely, as motorists, to resent, berate, and sometimes even attack pedestrians, joggers, and other motorists who occupy part of the road. The key condition that facilitates this result seems to be that people are enclosed by different spatial boundaries, are moving at different speeds, and have no adequate mode of communication and little mutual understanding about how to stay out of each other's way in unforeseen circumstances. Psychological isolation occurs in spite of total visibility. Indeed, this is the kind of visibility that increases alienation because, like visibility in a prison or psychiatric ward, it is experienced as surveillance and threat. In such settings visibility and proximity only emphasize the impossibility of communication.

Clearly, spaces do not themselves create self-conceptions or perceptions of others, but rather simplify and intensify beliefs and perceptions that already exist. In doing so, they inevitably select from among the possibilities to which every person is susceptible. Probably more important, they evoke the same intensified and simplified perceptions in groups of individuals for whom a particular kind of space becomes significant.

That some settings evoke alienation and some symbolize common interests becomes especially important in a bureaucratized world. Decisions affecting the quality of people's lives, and even

their duration, are made by officials, administrators, and professionals, who use abstract data rather than personal interaction as their premises. The critical space is not the homestead, the entrepreneur's personal office, the neighborhood, or any other environment in which people engage in direct intercourse about their livelihoods or their recreation, but rather the specialized bureau, the docket, the computer memory, and the filing cabinet that categorize people according to some abstracted quality and therefore treat them as part of an alienated universe. And the alienation in its turn creates a need for symbols of a common interest and a persisting social order. As already noted, spaces fulfill this reassuring psychological and political imperative as well, the same public space often serving both dialectical functions. The subtle influence of spaces as symbols of the kinds noted here becomes a more and more central aspect of politics, society, and personality.

LIMITED AND UNIVERSAL CLIENTELES

Some spaces become significant symbols only to limited clienteles for whom they serve a vital purpose, while they remain insignificant or unknown to most of the public. A usually small minyan of Orthodox Jews, for example, meets every morning and evening for prayers, typically in a small room in the basement of a synagogue. The scene is characteristically unpretentious, even drab; but for the pious participants it becomes a sacred setting, and perhaps more moving in its connotations than a large and lavishly appointed synagogue could be. As suggested earlier, it is the meaning read into a scene, rather than its physical properties as such, that is critical.

Still, the politically important effects of symbolism are those that shape the perceptions of the general public, even when the symbol also conveys special meanings to smaller groups. Several examples already cited exemplify the power of structures and spaces to establish and reaffirm hierarchies of values for a society: to define both goals and people as important or as expendable, and to spread such values to a wide public.

Some kinds of structures are more enigmatic about the values

they reflect and evoke; the questions they raise are less clear than in the instances cited above. The Illinois Agricultural Association objected some years ago to a proposed undergraduate library at the University of Illinois in Urbana because its shadow would have fallen during part of the day on the Morrow Plot, an acre of farmland in the middle of the campus long used for crop experimentation. Alternative land was plentiful in the central Illinois prairie, so it was the historic and symbolic associations of the Morrow Plot that were at issue, not its unique utility. The undergraduate library was constructed underground, so it casts no shadow. It is tempting to see this resolution as a reflection of the high place accorded agriculture in Illinois politics and folklore (a ranking that must be expressed symbolically with all the more fervor as the population of the state and the nation becomes more lopsidedly urban). It may also be a more general expression of deep ambivalence about higher education in relation to other values. In this instance the conflict of values took the form of burying the undergraduates and their books while still giving them their library. The large appropriations of midwestern states for public universities have often been accompanied by a strain of antiintellectualism and of suspicion of the cosmopolitanism and alleged effeteness that some believe universities instill in students.

MULTIPLE MEANINGS AND OVERDETERMINATION

It seems apparent that various kinds of needs ordinarily categorized as separate serve in practice to complement and reinforce one another: psychological needs for self-fulfillment; economic and status needs for the problematic definition of other people in a way that makes them available for use and abuse; and political needs for the maintenance of an established social order in which, whatever its pathologies, people accept their respective roles. The meanings of public spaces are therefore almost certainly overdetermined, in both the Freudian and the Althusserian senses of that concept. The overall social structure is reflected in self-concepts, in economic transactions, in the political order, and in the meanings architectural structures assume.

One way to examine overdetermination is to analyze in just what sense spaces serve as condensation symbols. As Freud recognized, the energy and affect attaching to one kind of perception of an object can be invested into other kinds of objects (cathexis), so that the latter evoke passions out of proportion to their intrinsic importance. The eagerness of some car drivers to flaunt the mechanical power they control and to define others as targets may, for example, reflect their resentment and anxiety about their social, economic, and political powerlessness as individuals. Their use of a particular form of space occupancy to express such resentment is all the more feasible because they are unconscious of the source of their feelings. Spaces in general present themselves as having an explicit use function and an aesthetic function; that they can also condense psychological and economic anxieties people do not want to face makes them all the more potent as political symbols, for the explicit function covers for the unconscious one.

Yet the very concurrence of psychological, economic, and political meanings calls attention to a constraint on the symbolic range of spaces: they play their parts only within the context of the hopes and the fears of specific social situations. They reinforce, condense, and reify perceptions, beliefs, and feelings that grow out of such social relations as dominance and dependency, alliance and hostility, anxiety about threats, or anticipation of future well-being. It is not, then, the automobile or the Pentagon war screen as such that makes targets of other people; rather, it is the potentiality of a hostile encounter that gives these spaces their meanings.

This discussion has emphasized those evocations that contribute to the acceptance of established roles, but some structures and settings manifestly stimulate the imagination and the individual creativity of spectators. It hardly needs to be demonstrated that striking and original conceptions in the design of buildings encourage the onlooker to think in unconventional terms, even about matters that have no obvious connection with architecture. But that is simply to say that spaces can stimulate intellectual play in

individuals even while they catalyze socially reinforced perceptions in collectivities.

Some studies have explored aspects of the social symbolism of spaces and structures other than those considered here, such as the psychological effects of crowding[7] and the phallic and other connotations of structural forms.[8]

That spaces fulfill so many functions simultaneously is added evidence for a point suggested earlier: that the conspicuousness of public structures, together with their emptiness of explicit meaning, enables them to serve as symbolic reaffirmations of many levels of perception and belief arising from the aspirations, harmonies, and conflicts of everyday life. The very density of their symbolic archaeology, the richness of their concurrent meanings, makes it more likely that any particular level will remain subconscious and mystified. Even when the associations of a space, setting, or structure seem clear, it is likely to be a deceptive clarity.

The multiple realities for which public spaces stand contribute, then, to social order and to social and political support for established hierarchies of status and power. They do so by helping individuals to reconcile ambivalence in themselves and ambiguities regarding the social world, to turn from one meaning to another, or to defy logic by holding several incompatible cognitions at the same time. To a pluralist this is an aspect of democracy; to a Marxist it can be false consciousness. In any case, an ongoing society is as inconceivable without the symbolic functions of buildings and spaces as it would be without their physical and technological functions.

7. Edward T. Hall, *The Hidden Dimension* (New York: Doubleday Anchor, 1969).

8. Sigmund Freud, *A General Introduction to Psychoanalysis* (Garden City Publishing Co., 1943), pp. 133–50.

Art as a Component of Government

The most direct way in which art and politics are related lies in the injection of art, artfulness, and spectacle into governmental operations, modifying their meanings and accenting hierarchical relationships between those who govern and those who submit to their rule. The presentation of politics as a form of aesthetics includes the deliberate or unwitting use of symbols and rituals in political processes in ways that obscure their roles in allocating values, and it enhances the ability of officials to influence and dominate the public.[1] The prominent reliance upon spectacle, ritual, and symbol in the Third Reich is the prototypical case, but the practice is pervasive in democratic states as well.

This chapter examines some groups of people whose authority, power, or vulnerability to the power of others are conspicuously shaped by such symbols and rituals, which also influence virtually the entire population in some measure.[2] This discussion is therefore intended to help readers understand the place of the deployment of spectacle and art in governmental processes generally, not to depict the groups analyzed here as exceptional.

I first consider in some detail the role of these forms of art in constructing the authority and vulnerability of trial judges and welfare applicants. Both these groups are numerous in contemporary society, and they offer a revealing contrast, both in the influences art exerts on their well-being and power and in their respective social status, authority, and political influence.

It is strikingly true of both of them, moreover, that their

1. Cf. the observations on politics as aesthetics in Walter Benjamin's essay "The Work of Art in the Age of Mechanical Reproduction."

2. Some of my earlier writings examine symbols and rituals, but do not specifically address their roles as aspects of the introduction of art into ordinary governmental processes.

depictions over centuries in many types of art have constructed them into such well-defined categories that in some measure they become roles rather than human beings, stereotyping their meanings and therefore limiting their possibilities for political maneuver. The latter part of the chapter examines the role of art in some other governmental operations more briefly.

TRIAL COURTS

So far as the judicial system is concerned, the trial court is the appointed site of spectacle. The trial is staged as a dramatic conflict, and though the facts, the issues, and the law are often unclear and in dispute, one party is destined to be a winner and the other a loser. The stakes may be high for both.

The court setting is highly formal, as are the roles of judge, jury, attorneys, witnesses, and spectators. Even the arrangement of furniture calls attention to those roles and to the relative status of participants; so do the rules about when judges, attorneys, and witnesses may speak and what they may say, and about the inability of jurors or spectators to speak at all during the formal proceedings. Lawyers' rhetoric is likely to be dramatic so as to appeal to jurors and a wider public, and the adversary counsels construct conflicting story lines that give evidence contrasting meanings.[3]

The trial is a sequence of incidents that create suspense and major or minor victories and defeats. These include selections and dismissals of prospective jurors during the voir dire, objections and rulings on them during the trial, and confidential conferences at the bench. The jury's verdict, the judge's sentence after a conviction for a criminal offense, and the public manacling of the defendant after imposition of a prison sentence are climaxes after a lengthy period in which tension has mounted. The theatrical

3. W. Lance Bennett and Martha Feldman, *The Reconstruction of Reality in the Courtroom* (New Brunswick: Rutgers University Press, 1981). For astute analyses of the construction of story lines in rape trials, see Kristin Bumiller, "Fallen Angels: The Representation of Violence against Women in Legal Culture," *International Journal of the Sociology of Law* 18:125–42; and Kristin Bumiller, "Rape as a Legal Symbol," *University of Miami Law Review* 42:75–91.

conflict builds up for all who are interested in the case and the issues it presents, not only for the audience in the courtroom. Because the trial setting is inherently dramatic, it is a favorite of playwrights, novelists, and mystery writers as well as journalists; trial scenes in works of art influence the behavior of participants in real trials at least as much as real trials influence their counterparts in art—probably more so.

In this perspective, then, the trial is a ritualized art form. Ritual and spectacle serve the general purpose of influencing public perceptions and public opinion. In the case of trials the purpose is clear enough: to legitimate the political and judicial systems generally, as well as the penalties and rewards that issue from a particular trial. Formality, ceremony, and the inculcation of awe and intimidation as aspects of the trial spectacle are artful creations that are necessary precisely because the fairness of the trial, the verdict, the awards, and the sentences are always in question for a part of the concerned public, sometimes a substantial part. Verdicts and sentences are bound in some measure to be arbitrary and to reflect the values and biases of judges and jurors. Judges are commonly suspected of associating with elites and of identifying with others who enjoy relatively high income and status. Jurors reflect the biases of particular communities or parts of communities rather than a nonexistent general code of fairness. The need for legitimation of their actions is compelling to assure quiescent acceptance of the outcomes of trials and of the policies that flow from the judicial system.

The judge's role is especially revealing in these respects. In the courtroom the trial judge enjoys virtually absolute authority and an exalted status that traditional rituals underline: the audience rises when the judge enters the room; she is addressed as "Your Honor"; her seat is elevated; lawyers must ask permission to "approach the bench"; the judge can punish lawyers, witnesses, or spectators for misbehavior, including insufficient respect for the court; and the judge exercises the most dramatic individual authority known in a democracy: to determine the severity of punishment of people convicted of violating a law.

As a form of address, "Your Honor" illustrates the observation of the eminent social and literary critic Kenneth Burke that it is a common function of political rhetoric to "blunt the too sharply pointed."[4] In this instance the usage mitigates the force of common knowledge or suspicion that judges' rulings are not necessarily shaped by honorable motives or dispassionate reflection. Similarly, such common clichés as the claim that a judge is "stern but fair" can help convert severe, draconian, or sadistic sentences into exhibitions of fairness. Whatever else they are, these ceremonies, behaviors, language patterns, and public exhibitions of power are art forms that convey a clear message about the constraints applicable to citizens. They are bound to influence the self-conceptions of judges and citizens, elevating the former and constraining the latter.

While courtroom ceremonies take place in a setting that purportedly exemplifies the rule of law, in practice they legitimate discretion that can be arbitrary. It is evident that ritualized rhetoric about the rule of law and due process serves to make the dictates of an official acceptable by masking the arbitrary authority that he exercises or by confusing spectators about what is taking place. Such blends of inconsistent rhetoric and action appear wherever power that might be challenged is exercised.

But in the most important sense the entire spectacle of the trial is itself a drama that masks the site of power. For while the judge's power is eloquently dramatized in the courtroom, its scope is narrow, and it becomes effective only when it conforms to the interests of those who command the largest resources in society. Judges' decisions are reversible in appeals courts, are dependent on legislative actions, and in some instances are modified by the interpretations of administrators. Thousands of lawyers of varying competence fill the position of trial judge, which ranks near the bottom of the judicial hierarchy. Incumbents are typically unknown outside their own communities, and are often little known even within those communities. Clearly, the drama inherent in

4. Burke, *A Grammar of Motives,* p. 393.

trial proceedings has a different function from the exercise of broad power or the formulation of national policy; we have already seen that it influences opinion so as to win acquiescence for particular decisions that might otherwise bring public resentment or resistance.

The trappings of power that trial judges enjoy are decidedly greater than their actual power—another way of making the point that spectacle is a paramount issue here. Indeed, the trappings are greater than they are for officials who wield far greater power and much more decisive influence over policy, including appellate judges, legislators, administrators at all levels, and all but the highest executives. For the criminal cases that come before trial courts, prosecutors also typically exercise considerably greater discretion than the judges through their authority to decide which charges will be ignored, which prosecuted (and how zealously), and which plea-bargained.

Trial judges are severely constrained in yet another way that is rarely apparent to the public and probably not usually apparent even to the judges. Their mandate to apply statutory, constitutional, and common law to particular cases means that there is a strong bias toward ignoring or minimizing the social and economic conditions that explain a great deal of the behavior that is found in violation of those laws. To put the point another way, the rules and the conduct of trials artfully place blame for illegal conduct on individuals who act rather than on the social conditions that often make it inevitable that they will violate the law. As Anatole France put it, the law in its majesty penalizes both the rich and the poor for stealing a loaf of bread or sleeping under bridges.[5] In this way the law helps judges to rationalize classist, racist, and sexist actions with a clear conscience.

A morality play lies at the heart of criminal trials, then. It

5. Anatole France, *Penguin Island* (New York: Random House, 1984). The novelist actually understated the degree of discrimination and unfairness because while the poor are punished for stealing necessities, a rich person who did so would almost certainly be treated as mentally unsound or as guilty only of eccentricity or imprudent practical joking.

features the virtuous judge punishing the defendant who has sinned, thereby protecting society from further transgressions. This is a reassuring drama, readily accepted with approval by its audience most of the time.

But a different drama might alternatively be read into a high proportion of the proceedings and typically is not. In this tragedy, people victimized from birth by poverty, want, abuse, poor schooling, and the deprivation of virtually any prospect for a rewarding life are further punished for actions that are inevitable for a great many of them in light of their circumstances.

Why is the first narrative generally accepted without doubt and the second rarely even considered as a possibility? Incarcerations on a vast scale have not diminished the incidence of crime—in fact, have almost certainly increased it. Studies show that they rarely rehabilitate or deter, and they make it impossible for most released inmates to survive except by resort to crime. The second narrative, moreover, fits the findings of social science far better than the first. The morality play blames a sinner for the ills of society and assures the public that evil is being countered, while the tragedy shows that only a radical restructuring of the social order could effectively deal with crime, and it depicts the law as blaming and punishing victims as much as their initial victimization did. The first story is reassuring and so readily accepted. The second is strongly threatening, especially to those who wield the greatest influence over public policy.

Indeed, the imposition of a sentence on a defendant in such situations is more significant and more gratifying for elites because of what it denies than because of what it affirms about the guilt of the individual. Because it denies that the structure of society and gross inequalities in wealth, power, and privilege are responsible for crime, it repudiates as well any suspicion that the pervasiveness and growth of crime call for change in social structure or in the distribution of rights. In a critical sense, then, the official and ritualistic visitation of blame and punishment upon the individual is a form of escapist art that plays to the general public as well as to the participants in the courtroom drama, doubtless

including the defendants themselves as well as the judges, prosecutors, attorneys, and jurors whose economic and ideological interests that view generally promotes.

Ceremony and deference to the judge are necessary at the trial level because it is here that public attention is focused. The action must therefore be visibly under the ultimate control of the one court official who symbolizes blind justice and impartiality, for all the other participants are either explicitly partisan, like the attorneys, or visibly susceptible to bias from their backgrounds or the attorneys' arguments, like the jurors.

Juries are supposed to reflect the values and perceptions of the local community even though other communities may regard them as blatantly biased. At the same time, the symbol of impartiality is also applied to juries, especially in the voir dire and in justifications of changes of venue. Here again, a favorable standard neutralizes an inconsistent derogatory one to rationalize outcomes; in this case, impartiality in principle may rationalize prejudice in practice.

The trial must satisfy the interested public that its outcome was legitimate, especially when feelings about a case run strong. More important, though less visibly so, court spectacles in general (and especially publicity about the sentences they impose) are designed to intimidate the public into acquiescence to prevailing norms of conduct if there is any substantial disposition to violate them. It must create and maintain widespread fear of punishment for deviations from what the courts proclaim is law.

The law takes the form it does, of course, precisely because there *is* significant inclination in the society to do what it forbids; without such an inclination, criminal law on any subject is unnecessary. The proclivity is present because violations of the legal code are often natural and enjoyable forms of behavior, as Freud recognized,[6] and because it is often apparent that the law operates unfairly, usually benefiting elites and hurting or repressing large segments of the population. Once again, we see the uses of

6. Sigmund Freud, *Civilization and Its Discontents* (New York: Norton, 1989).

incompatible themes in political maneuvering. In the case of the court spectacle the publicized focus on impartiality and rationality masks and rationalizes the implicit focus on fear and intimidation. Similar combinations and confusions of themes and motives are characteristic of other art forms as well, notably dramas, stories, and novels.

The criminal justice system is unique among governmental spectacles because its paramount function is to threaten and warn even while it also offers some reassurance, whereas the other great spectacles are merely reassuring. The leading example of spectacle elsewhere in the governmental process is elections. There are also national holidays, especially Independence Day, Memorial Day, Presidents' Day, and Martin Luther King Day, and there are ceremonial occasions like the naturalization ceremony and inaugurations of high executive officials. Repeated reassurance is psychologically necessary to the degree that people feel anxious, though none of these occasions, except perhaps elections, is as critical to social stability as the trial courts are.

Even though the judges' decisions are quite narrowly constrained, they can be crucial for defendants, prosecutors, and plaintiffs in particular cases, and sometimes for others similarly situated. They help maintain and legitimate a social system that allocates benefits and penalties unequally, minimize unconventional expression of discontent, and help avert severe political challenges and rebellious action. They are likely to be overturned by appellate courts or legislative bodies when they counter these purposes. But in spite of the parameters that shape them, the judges' decisions are accepted as the expression of personal discretion. The rituals and symbols attending trials, then, create the spectacle of a fair, impartial, democratic process and great personal power, displacing unfair, undemocratic everyday life, and they mask a judicial role that is driven by the imperatives of the established political system.

In these ways a spectacle constructs the presumption that justice is done. Any careful examination of the constraints and the unequal resources in wealth, knowledge, and public sentiment that

mark trials, on the other hand, must conclude that they bring a legal resolution of issues and disputes, but not necessarily a fair one. Nor does the adversary system of eliciting evidence offer any assurance that there will be adequate presentation of relevant facts or cogent analysis of their meaning. There is no necessary connection between law and justice in trials, but the influence of trials on public opinion, and their legitimation of governmental institutions, is certain.

WELFARE APPLICANTS

Just as some public rituals, myths, and spectacles underline the high status and authority of judges, so others construct welfare claimants as suspect, unwilling or unable to earn a living in a respectable way, and therefore low in status and subject to the authority of welfare officials, even respecting their lifestyles and types of decisions that more affluent people regard as personal and private in their own lives. Sometimes these art forms are deliberately contrived to influence public opinion about the poor. Sometimes they emerge as a product of the environment that comes to be associated with the poor; that environment is itself both a material entity and a message about the worth and the morals of its occupants. It comes into being as a result of decisions by those who wield power and substantial resources; it is not fated, but constructed.

The conditions in which the poor grow up and live accordingly need to be recognized as art forms themselves, as well as obstacles to the good life. The environment becomes a never-ending drama that teaches people to be afraid, humble, subservient, ashamed, hopeless, or all of these. The components of this spectacle include the neighborhood that is conspicuously shabby and contrasts revealingly with affluent areas; lack of enough money to live "respectably," forcing people to behave in ways they have been taught to see as immoral, petty, or illegal; police patrols and other actions that remind residents they are distrusted, even as they offer some protection; deprivation of quality clothes and appurtenances that mark a desirable way of life, as pictured in advertisements

and in public displays by the comfortable; demeaning treatment by teachers, social workers, police, bureaucrats in welfare and other governmental agencies, employers, prison guards, and the armed forces; and repeated instances of humiliating and humbling behavior by acquaintances, neighbors, and relatives. The poor experience defeat constantly, know few victories, and can harbor little hope for change in these circumstances. Their lives, experiences, and settings instill degraded self-esteem and acquiescence to deprivation and powerlessness.

While these conditions that convey dramatic messages are by-products of the inequalities that are increasingly conspicuous in industrialized societies, their effects are bound to be exacerbated, rather than countered, by another set of art forms that are aimed quite deliberately at the disadvantaged and the powerless. The latter chiefly take the form of rhetorical reassurances intended to mitigate the resentments that flow from all too obvious deprivation.

Many of these focus on the ideal of equality among citizens, which is proclaimed in the Declaration of Independence, affirmed in the equal protection clause of the Fourteenth Amendment to the federal Constitution, and reaffirmed in state constitutions and other formal documents, in patriotic oratory, and in civics courses in the grammar schools. There are rhetorical assurances as well about America as the land of opportunity and self-reliance, as revealed by its nineteenth- and early twentieth-century history of immigrants who prospered here. People are repeatedly told as well that ours is a pluralistic society—sometimes a "melting pot" that converts aliens into Americans, sometimes the outstanding example of a society that glories in ethnic, racial, and religious diversity and in the power all groups enjoy to influence public policy.

For anyone with even a modest knowledge of American history, society, and politics, this list of reassurances calls to mind the conspicuous failure of the United States to live up to any of them. The one kernel of truth in this litany lies in the reference to the opportunities many immigrants, though by no means all, have found here. But while that picture of easy upward mobility held true in

the nineteenth and early twentieth centuries for many immigrants from Europe, it never did apply to African Americans, and for most of the twentieth century it has offered a false picture of the fortunes of Hispanic immigrants, who will soon be America's largest minority. Nor does it apply to many Americans displaced from factory and even managerial jobs in the last several decades. On the contrary, mobility has been downward for increasing numbers of Americans in the final decades of the twentieth century because of a long decline in real wages and the exportation of jobs to low-wage areas of the world.

Students of political language recognize all these forms of rhetorical reassurance as signals of trends that contradict their surface meanings, a common function of officially disseminated myths and other symbols. It is because the reassurances are misleading that they must be repeated often as official dogma. They offer an escape from a frightening or depressing reality.

The view that the personal inadequacies of welfare recipients explain their failure to take advantage of the many opportunities offered them is especially reassuring to much of the middle class. It can be taken as evidence that the latter group is more competent and virtuous. In recent decades, moreover, the middle class has been suffering from high rates of unemployment, burdensome taxes and prices, and declining real wages, instilling well-grounded fears that these people may themselves slip into poverty at any time. In this situation it becomes all the more important to distinguish themselves from welfare recipients in terms of their own more "wholesome" values, and to see welfare spending as the explanation for their onerous taxes and their precarious place in society.

In this way economic trends evoke a compelling drama about virtue, vice, the struggle for respectability, defeat, and survival. To the political analyst, economic statistics need to be understood both as abstractions and as the generators of an art form. The latter constructs a special reality in which individual delinquency accounts for welfare problems and behavior, even while it erases evidence that would raise doubts about the parable.

OTHER ARTISTIC CONSTRUCTIONS OF DUBIOUS BELIEFS ABOUT GOVERNMENT

Because the actions of public officials typically bring consequences that are hard or impossible to know, and because the officials' continued tenure and power depend on public beliefs about their accomplishments and inadequacies, there is a strong incentive to shape those beliefs to win favor and calm fears. Socialization to revere the form of government that prevails—especially the socialization of children—abets officials' efforts to cast their actions in the most favorable light. Art manifestly plays a decisive part in accomplishing that end.

Consider first the narratives that justify and rationalize the power, incomes, and perquisites of people who hold high executive positions. Executives draw upon a reservoir of myths about "leaders," myths that are taught and repeated often and doubtless have been in circulation as long as human beings have lived in hierarchies.

The master narrative holds that incumbency in a high executive position means leadership and merit. This story must be reiterated frequently because there is often strong reason to doubt it. High public officials achieve their positions far more often because they can be counted on to conform to established norms and practices than because they take a lead in innovating or in solving social problems.[7] Leadership in politics is more likely to come from individuals and groups who are striving for power rather than from those who already have it. But the identification of high position with leadership rationalizes the authority of executives and offers a powerful reason to acquiesce in their rule and their privileges.

Other traditional stories about heads of state and executives have frequently maintained public support for them, even in the face of tyrannical rule and incompetence. These narratives depict the top executive as above politics, at least in those aspects of

7. Murray Edelman, *Constructing the Political Spectacle* (Chicago: University of Chicago Press, 1988), chap. 3.

government that involve basic fairness, and they evoke the image of a benign ruler innocent of the mistaken actions of subordinates and ready to correct them when they come to his attention. Executives manifestly have a strong incentive to encourage the circulation of such myths, and anxious publics and subordinates recurrently find it reassuring to accept them. The practice of initiating dubious policies in such a way that the highest executives can plausibly deny that they authorized them or knew about them if they later become embarrassments is an aspect of this art form as well.

Related narratives justify the questionable actions of administrators in less exalted positions and protect them from responsibility for their controversial policies. In those circumstances administrators call upon a stock rationalization that invokes the sanctity of constitutional law, though the invocation is disingenuous. The predictable and ritualistic excuse in these circumstances is that the functionary does not make policy, but only carries out, in mechanical fashion, the laws mandated by elected representatives of the people. This artful invocation of what may, at first blush, look like a democratic principle ignores the whole point of creating administrative agencies: that their mandates are always vague precisely because that course of action takes legislators off the hook respecting controversial and often unpredictable dilemmas. Administrators are therefore not only able, but required, to make policies that help some and hurt others, and to do so with little or no guidance from the legislature. But a large measure of the legitimate democratic criticism of their decisions is blunted or screened from attention by an artful and ritualistic narrative that leaves no one responsible for mistakes, unfairness, or inaction.

Such abuse of democratic theory to absolve officials of responsibility for their actions appears throughout the governmental process. Just as administrators cite statutes as their rationales for pursuing policies that the statutes do not specify, so legislators and elected executives cite elections as providing the mandates that authorize whatever policies *they* pursue. But here again the rationale is largely a public relations ploy. Because campaign promises

and platforms are most ambiguous in regard to precisely those issues that are most controversial, election mandates are figments of the imagination. In a brilliant recent study Marjorie Hershey demonstrated that election mandates are like Rorschach ink blots, semantically empty symbols into which officials and interest groups project whatever content suits their ideologies.[8] When officials cite election mandates as the justification for their controversial actions, they draw upon a work of art posing as a democratic practice.

Elections are powerful symbols, myths, and rituals in several important respects. They chiefly symbolize the will of the people and therefore sanctify the entire governmental process as democratic because they can be cited as the basic influence on all of it, directly or indirectly. The officials who act and prescribe policy are either elected themselves or appointed by those who are; and in principle the electorate can change policies by removing from office those officials who have pursued policies the public does not like.

This reassuring account only rarely has much bearing on actual governmental operations. Harmful or disastrous conditions can only occasionally be traced to the actions that generated them, and it is easy to create misleading impressions about causes and effects in this regard. Policies that have only a trivial effect on the well-being of the population, or none at all, often become crucial in election decisions because they evoke strong emotions. Voters invariably confront a record that includes some actions they like and some they dislike, and only the rare voter knows the record in any case. It is apparent that elections legitimate governmental actions much more effectively than they influence them. Yet art constructs elections as the foundation of democracy; appeals to vote and social pressures to do so reinforce that effect.[9]

In the late twentieth century, elections in the United States may

8. Marjorie Hershey, "Constructing Explanations of Election Results: When the Voters Have Spoken, Who Decides What They Said?" in Richard Merelman, ed., *Language, Symbolism, and Politics* (Boulder: Westview Press, 1992), pp. 85–122.

9. For a detailed discussion of myths about elections, see chapter 8.

be in danger of losing their legitimating force because of the steep trend toward nonvoting. With nonvoters almost always a larger group than the voters who support the winner, it may become harder to see elected officials as the choice of the people; but even though nonvoting is massive, there is little evidence that delegitimation has yet begun—a striking tribute to the continuing potency of the election myth.

The concept "public opinion" evokes a related confusion that is also a product of art implicated in the governmental process rather than of experience or logic. In this case it is chiefly tropes referring to the alleged phenomenon that build a dubious picture of it in our minds. Officials are "swayed by public opinion" or they "resist" it or "yield" to it; public opinion requires them to act or prevents them from acting.

The term evokes a compelling image, in short, of a tangible force or wall that is independent of officials and that shapes or modifies what officials and candidates can get away with. It is a reassuring picture that minimizes fears of oppressive political or bureaucratic power, but it is also a blatantly misleading one. For one thing, officials and interest groups themselves create most of the "opinion" to which they then respond; they do so by arousing fears of threats and enemies or by evoking hopes of an attractive future. And far from being tangible, opinion is often evanescent and volatile, changing with the social situation, with current news reports, and with how an issue is categorized.[10] It is not so much a characteristic of people's minds as an invention, often unselfconscious, of those who stand to gain materially or ideologically from belief in it. But the metaphors that evoke such belief are readily created and can be potent.[11]

Another form of the construction of belief and public policy through art deserves special attention because of its frequency and its marked consequences for well-being: the evocation of hos-

10. See chapter 7.
11. For an extended discussion of this remarkable phenomenon see Edelman, *Political Language,* pp. 49–55.

tility or friendliness toward foreign countries. Here the remoteness of almost all citizens from the diplomatic scene and from unfolding developments in particular foreign countries makes it especially easy to influence public response through appeals to biases, myths, lies, and reminders of alleged historic friendships or animosities. Racial and ethnic prejudices, atrocity tales, evocations of trust or repugnance toward a foreign leader, incitements of hope or fear regarding the future—all play a role and are easy to elicit. With even greater facility than in the case of domestic policy, therefore, officials and interest groups deploy tales, dramas, movies, rumors, jokes, cartoons, and other art forms to support a hostile or friendly stance toward other countries, and sometimes toward regions, races, religions, or ethnic groups throughout the world.

The examples reviewed here hardly begin to depict the overpowering influence of artistic creations throughout the governmental process. And that is, of course, inevitable. We have to react to pictures, stereotypes, and tropes because it is simply not possible to learn about complex and controversial public issues in terms that might be empirically and logically verified. There are too many issues; there is no way to comprehend them objectively; and, in any case, our minds do not work that way.

But if reliance on art to define political issues is unavoidable, it need not be distorting, as it usually is. As the examples discussed here illustrate, the art that serves this purpose is too often kitsch: artful evocations and reinforcements of existing biases and self-serving ideologies. Kitsch constructs a term like *family values* to evoke a romanticized middle-class family displaying the moral commitments that exist in idealized bourgeois ideology but not in the world in which we live. Othello and Lear, by contrast, depict the strains that explain why "family values" in the romanticized sense have little to do with life. So do the works of Balzac, Dickens, and every other serious writer. These works of art tell us about the life we encounter. The expression of political issues in terms of aesthetics, by contrast, is a particularly virulent form of

false consciousness; it paves the way for subordination of individual autonomy to the interests of an elite. It was that contrast between the strains and joys of everyday life and the romanticization of ideology that Walter Benjamin meant when he warned that the treatment of politics as aesthetics is a move toward fascism.[12]

12. Benjamin, "The Work of Art in the Age of Mechanical Reproduction."

Contestable Categories and Public Opinion

Works of art stimulate their audiences to see the situations they create from a particular perspective. They classify those situations as one kind of entity rather than alternative ones that might apply: as heroic or tragic or racist or calamitous or funny, for example. The construction of categories is central to the effects of works of art. That phenomenon deserves close scrutiny.

Chapter 1 calls attention, for example, to a set of depression-era novelists, playwrights, and painters who made poverty vivid for Americans and made them feel its miseries, so that public welfare came to be categorized by most of the public as a justifiable aid to the needy rather than a drain on the public treasury. In several of his novels Charles Dickens helped change the categorization of boarding schools and of nineteenth-century capitalism from desirable to dubious social institutions.

In his rather difficult concept "structures of feeling," Raymond Williams helps explain what is involved in such changes in categorizations and in conflicts about their proper applications. He writes of "affective elements of consciousness and relationships; not feeling against thought but thought as felt and feeling as thought: practical consciousness of a present kind, in a living and interrelating continuity." [1]

Governments grant benefits (sometimes lavish ones) to some people and impose deprivations, pain, and misery upon many. They can win public support for these actions only by creating and spreading beliefs and emotions about who is deserving and who is a threat; about which policies will bring desirable results

1. Raymond Williams, *Marxism and Literature* (New York: Oxford University Press, 1977), p. 132.

and which will be painful, unfair, or disastrous; in short, about what causes what.

We are seldom aware of how easily and frequently our beliefs about policy preferences, causes, and consequences are created and changed by subtle or unconscious cues. Quite the contrary: we ordinarily assume that we live in a world in which the causes and consequences of actions are stable and fairly well known. Neither the media nor academic studies pay much attention to the fundamental political work that makes the benefits and the deprivations politically possible: the creation and remolding of public beliefs and feelings about the causes of particular outcomes, thereby justifying some actions and building opposition to others.

That kind of creation and remolding ultimately depends on change in conception and perception: on seeing something as a different entity or envisioning it from a transformed perspective. Such metamorphosis is common and easily brought about. Works of art do it all the time; it is, in fact, an essentially aesthetic process.[2] Art teaches us to see the world in new ways, and the creation of categories provides one kind of aesthetic lens through which conception and vision are constituted or reconstituted.

What we "know" about the nature of the social world depends on how we frame and interpret the cues we receive about that world. Those cues would be a blooming, buzzing confusion if our minds did not give them particular meanings by focusing on a few and ignoring most, and by placing those that receive attention into specific categories. A war may be named a noble crusade (in which case the killing of innocent civilians and the profiteering the conflict brings, for example, are minimized); or it may be labeled an act of unjustified aggression, in which case carnage and profiteering become a major focus of attention, and claims about the national goals to be realized from victory are repressed.

2. One definition of *aesthetics* in *The American Heritage Dictionary of the English Language* reads, "In the philosophy of Kant, that branch of metaphysics concerned with the laws of perception."

The character, causes, and consequences of any phenomenon become radically different as changes are made in what is prominently displayed, what is repressed, and especially how observations are classified. Far from being stable, the social world is therefore a chameleon, or, to suggest a better metaphor, a kaleidoscope of potential realities, any of which can be readily evoked by altering the ways in which observations are framed and categorized. Because alternative categorizations win support for specific political beliefs and policies, classification schemes are central to political maneuvering and political persuasion.

Categorization is, in fact, the necessary condition of abstract thought and of the utilization of symbols in reasoning and in expression, the distinctive abilities of Homo sapiens. Alternative categorizations change meanings, often radically. But in statements about politics the choice of categories is typically driven by ideology and prejudice rather than by rigorous analysis or the aspiration to solve social problems.

Categories are especially powerful as shapers of political beliefs, enthusiasms, fears, and antagonisms when they appear to be natural, self-evident, or simply descriptive rather than devised as propaganda tools. The labeling of a war as either "noble crusade" or "naked aggression" reeks of polemics and so evokes suspicion and resistance in many. But the same war's characterization as "foreign policy" or as "military action" looks at first blush simply like realistic description. Yet those labels are also examples of arbitrary highlighting and exclusion, and they are vital to the construction of public support. The category "foreign" excludes from attention the crucial ways in which domestic policy influences the outbreak and nature of war, and is in turn decisively influenced by war or preparation for war. War is domestic policy as much as foreign policy, but to classify it that way immediately creates different beliefs about its causes and consequences. For the same kinds of reasons, international economic conditions are both domestic and foreign in their origins and impact. The category "military" similarly minimizes the enormous impact of war on the civilian population. The skewed labels "foreign" and "military"

win wide discretion for officials, diminishing popular influence on policy.

But categories are usually even more complicated and more powerful as creators of meanings than those examples suggest. Each term that names a category brings other resonances into play, and these proliferate into still other connotations and categories indefinitely. The term *enemy,* for example, carries many undertones: Satan, temptation, crime, evil, lower class, and others. The term *red* may call to mind a color, blood, communists, American Indians, danger, and more. While one connotation may be dominant in a particular context, the others remain latent or subconscious and often influence response.[3] The many potential categories implicit in each explicit one also facilitate the creation of networks of categories that reinforce each other, an attribute of political discourse considered below.

Deliberate propaganda is therefore not the fundamental reason people are frequently misled about which governmental policies and which candidates for office will help them and which will hurt; which groups should be blamed for policy failures and social problems and which accepted as competent and deserving. Propaganda is effective or ineffective according to how well it reflects underlying beliefs about the ways in which desirable or undesirable policy outcomes can be brought about; and those beliefs flow, in turn, from the construction of special realities through categorization. The misrepresentations of sound bites, contrived images, lies, and other inventions of public relations consultants find a receptive audience only when they reinforce hopes and fears that classifications of people and actions have already created. Otherwise, they are recognized (and classified) as propaganda and dismissed.

3. For some observations that bear on such resonances, see E. H. Gombrich, *Meditations on a Hobby Horse* (London: Phaidon, 1963), chap. 2.

Contestable Categorizations

A major reason for misreadings about central political issues lies in the dubious ways we classify news stories about public policy into discrete and autonomous spheres, and so foster false beliefs about the causes of problems and the consequences of governmental actions. The prevailing classification schemes obscure the close links among developments they routinely categorize into separate domains: domestic; foreign; military; economic; crises or routine developments; benefits to particular groups; actions that reflect personality or individual character; or the promotion of widely supported goals, like education and environmental protection.

Each such label highlights some immediate, surface aspect of a governmental policy while obscuring the close links among related policies and related categories. The classification therefore misleads opinion about the origins of problems, their effects, their scope, and effective remedies. At the same time, the conventional categories *are* effective in winning and maintaining public support for established hierarchies and inequalities, as discussed below. Whether they are "mistakes" therefore hinges upon the values and ideology of the observer. This pervasive influence on public opinion is rarely noticed. Indeed, its remarkable power is closely tied to its invisibility and to the assumption that the common classifications and the cause-effect relationships they imply are objective and self-evident.

The common classifications obscure the important ways in which policies in supposedly different categories reinforce each other—a phenomenon analyzed below, as is the incentive for regimes and the media to employ neat, narrow categories that appeal to strong emotions, camouflaging their wider consequences, which are more complex, less clear, and therefore less useful for mobilizing public opinion.

THE PERSIAN GULF WAR AS AN EXAMPLE

The Persian Gulf War of 1991 offers a revealing example of the influence of misleading categorization upon politics and opinion. The war was publicized as a military and foreign policy concern: a classification that encourages the public and Congress to grant the widest policy discretion to the White House and the Pentagon (as noted earlier); to accept public sacrifices as necessary and patriotic; and to focus on military considerations as paramount. But this perspective, powerfully disseminated by a seemingly self-evident label, concealed most of the consequences of the war.

It obscured the remarkably unequal pattern of sacrifices and benefits by constructing a compelling metaphor of a foreign enemy threatening the interests or "way of life" of the American nation. But the enlisted men and women and the junior officers sent to the Arabian desert to work under conditions of extraordinary hardship and vulnerability to being maimed or killed there were disproportionately of the lower middle class or poor, and disproportionately black. They were in the armed forces largely because the high levels of unemployment and underemployment in the city ghettos and among young people over the last several decades have encouraged those with no other options to enlist or join the reserves in order to support themselves and their families or pay for their schooling. So have falling real wages and the tightening squeeze on poor and lower-middle-class families for adequate income and for the resources to attend college. To describe people in this situation as "volunteering" for the armed forces or the reserves is formally accurate, but blatantly deceptive in its psychological, political, and moral implications; it is still another instance of an ideological and contestable categorization.

In the language we ordinarily deploy to describe the situation, economic conditions amounting to coercion to curtail civilian careers and risk lives disappeared from view, while a military label for governmental policies in the Gulf stimulated the media and the public to define the motives of the troops as patriotism and eagerness to "serve their country." By contrast, the recruitment litera-

ture that helped induce them to enlist stressed a different categorization for the peacetime armed forces, constructing organizations that help enlistees pay for an education, learn useful skills, and see the world.

The labeling of the Gulf War as a military and foreign policy issue also obscured understanding of the monumental political and economic benefits that flowed to some from the preparations for war in the Gulf region. The "peace dividend" that had threatened for a short time to restore some of the massive Reagan cuts in programs for the poor, the sick, the schools, the cities, housing, and the environment disappeared, while the military budget was rescued from steep cuts and could continue to enrich suppliers of military goods and services and to promote the careers of civilian and military officials in the defense department. The White House basked in "rally 'round the flag" sentiment, especially in Congress, while public wrath over the savings-and-loan scandal was diverted and blunted, as was the disposition to oppose other presidential actions, such as the sale to Saudi Arabia of massive amounts of technologically sophisticated armaments, the embracing of President Hafez el-Assad of Syria as an ally after American regimes had long denounced him as a vicious terrorist, and the restoration of military assistance to the repressive government of El Salvador.

While there were certainly occasional media references inconsistent with the misleading but compelling set of categories, the latter radically restructured the political agenda and restored public support for conservative and militaristic policies.

The perverse effects of the dubious labeling go considerably farther because they convert controversial policies into self-fulfilling prophecies by sanctifying both their costs and their benefits. Young people and minorities eager to escape poverty and acquire an education or skills become patriots willing to risk their lives. The substantial profits of armaments contractors and the careerism of public officials, bureaucrats, and Defense officials disappear from view, becoming courage, toughness, proof that one is not a "wimp,"

and patriotism as well. In a revealing sense, both kinds of actors acquire a strong incentive to redefine their own motives along these lines. If poverty, money-making, easy promotions, and military dominance in civil society can so admirably be erased as problems and reconstructed as sources of patriotic actions, the incentive to do so becomes hard to resist.

OTHER DOUBTFUL CLASSIFICATIONS

That example is an easy one to understand because it involves an exceptional development with immediate and dramatic consequences. But the more durable and more typical misconceptions about who benefits and who suffers from public policies rest on classifications that reflect both a failure to connect effects with their causes and strong emotions based on class, race, gender, and other readily aroused sources of affects. These are even more likely than the Persian Gulf issue to be experienced as self-evident descriptions rather than contestable interpretations; they are therefore even more potent as influences on public support for policies and regimes.

Public alarm about violence in the streets, drug abuse, and uncontrollable crime exemplifies the point well. It is obvious from the "crime control" measures that are increasingly popular (in spite of their failure to make inroads on the incidence of crime) what model of cause and effect is paramount in the minds of legislators and much of the public. The fashionable belief, repeatedly revitalized by the rhetoric of public officials and candidates for elective office and by films, stories, and novels, is that crime springs from evil people who thrive on muggings, robberies, drug abuse, and murders. It follows that the way to deal with it is tough law enforcement, long prison sentences, capital punishment, and expansion of the criminal code to cover more and more kinds of behavior. The imprisoned population of the United States more than doubled in the decade of the eighties and is increasing at an ever faster rate in the nineties.

A controversial classification plays a decisive role in converting

the land of the free into the home of the jailed. At the same time it helps officeholders win reelection and helps conservatives defeat social programs. The facile evocation of inherently criminal types conceals the link between illegal activity and an economic and social system that denies large numbers of people the means to support themselves and their families. To break the law is in part a way of surviving and in part a form of social protest, usually the only effective way for people who lack money and status to express their anger at a social and political system that keeps them poor and dependent.[4] It becomes a way of life if the absence of other options continues long enough. Here again, a widely disseminated classification not only helps create emotional support for blaming the victims, but becomes a self-fulfilling prophecy as well. The labeling of large numbers of people as innate criminals and convicts ensures that for them and their families, breaking the law will remain the major option for survival and political expression, and often the only option, reinforcing the controversial categorization and constructing an ever more vicious circle of cause and effect.

Welfare benefits, to consider another example, are classified as relief and reform; but they are chiefly effective as a means of regulating the poor so as to maintain a large supply of cheap and docile labor.[5] Again, both the inadequate label "welfare" and the material benefit to employers buttress established inequalities.

The armaments budget, categorized as "defense," may well be the major influence on economic booms and recessions in industrialized countries with large military establishments. It influences regional prosperity or recession as well, and it attracts funds, scientists, and engineers available for research and development to military rather than peaceful uses. In serving these functions it

4. Cf. Frances Fox Piven and Richard Cloward, *Poor People's Movements* (New York: Pantheon, 1977), chap. 1.

5. Frances Fox Piven and Richard Cloward, *Regulating the Poor* (New York: Pantheon, 1971).

reinforces the inequalities already noted. The potent symbol "defense" is in part descriptive and in much larger part a rationalization for actions and nonactions that a more adequate classification would place under such rubrics as "economic," "scientific," and "social."

Many of the phenomena we always label as "social problems" (poverty, unemployment, discrimination against minorities and women) are not recognized as advantages for elites, though they offer major benefits for them. For employers, widespread poverty and high unemployment mean lower labor costs and a docile work force. For white males, discrimination against minorities and women means better jobs and reduced competition for themselves. "Liberal" legislation classified as efforts to solve these "problems" is chiefly responsive to the interests of those who benefit from the problems, and so is rarely effective in changing the discriminatory conditions, though there are often gestures sufficient to minimize social disorder and disruption. Both the minimal protections and the failure to solve the underlying problems maintain the established system.

Though most conventional classifications related to public policy are doubtless the result of long-standing confusions and socialization practices that reflect dominant ideology, some are deliberate efforts to secure economic advantage for a particular group. Construction workers, for example, are increasingly classified as "independent contractors" rather than as employees in order to avoid paying them unemployment compensation, workers' compensation, and social security benefits.

Because classifications of problems, issues, and policies are major influences on political support and opposition, those that carry a strong emotional appeal are favored. Unfortunately, the categories that focus attention on long-term consequences and on the implications of policies for the widest range of people typically carry less emotional appeal than those that concentrate attention on the immediate consequences of an action for a concerned group or individual. As a familiar line puts it, an opportunity

to win riches for oneself at the risk of death for an unknown, randomly selected Chinese is very tempting. In a more realistic and common example, business people often yield to the temptation to present as "quality merchandise" and "good buys" goods that will predictably harm unknown customers.

Voters often oppose tax increases for themselves at the risk of the local schools' becoming ineffective in educating children. Is the measure in question best classified as a tax bill or as an education measure? The Willie Horton ad in the 1988 campaign was presented as a dramatization of the danger of crime in the streets, not as a commentary on the long-term effects of prison overcrowding, denial of furloughs, or the ineffectiveness of imprisonment in reducing crime rates. The latter focus involves dry scholarship and statistics; the former hits close to home for many urban residents, even if its message is misleading.

A general label for a political ideology can create very different beliefs and emotions than names for the specific policies the category implies. To refer to enriching the wealthy, depriving the poor of the means to feed, clothe, and house themselves adequately, or executing a disproportionate number of poor and black people for crimes is to provoke reactions that are chiefly disapproving because those actions look unfair and shameful; but to refer to "conservative" policies is, for many, to garb the same policies in a perfectly respectable and even admirable aura. The category "conservative" evokes a picture in the mind of a place in a pattern of ideologies, all of which are respectable; but the specific labels for many actions conservatives favor evoke a picture of mean and unfair treatment of victims. The same hiatus between the connotations of a general category and the implications of specific ones it embraces appears in denunciations or exaltations of "liberal" policies that do not name the specific actions in question. In these instances a name drastically alters meanings and public reactions.

Sometimes the names of categories imply radical differences from other categories when the differences are in fact minor or

nonexistent. A recent study[6] calls attention to the impressive similarities among the experiences of African American slaves, Irish farm laborers, domestic workers and wives, and skilled artisans, journeymen, and other workers in London in the eighteenth century. None of these kinds of workers ordinarily received money regularly in payment for their labor; they all had to survive by helping themselves to some of the wealth around them in ways that were often illegal; and they all were vital to the work process. As one historian has put it, "In such circumstances distinctions between 'free' and 'unfree' labor, and between household and factory, which are so important to the history of the nineteenth century working class, did not cut nearly as deep."[7]

CATEGORIES AS AN INTEGRATED NETWORK

The list of favored and conventional categories and their associated confusions regarding causes and effects, benefits and sacrifices, and vicious circles could easily be expanded. Indeed, the set of contestable classifications regarding a wide range of public policies comprises an interconnected structure: a self-perpetuating system whose various parts buttress one another and so continuously buttress long-established inequalities. The most common ones exalt the actions and motives of elites and justify sacrifices for many others by defining them as less deserving, dangerous, unproductive, or parasitic.

The media, political regimes, and academic studies all typically focus on particular public issues, ignoring their close connections to other issues and policies. The treatment of closely connected issues as though they were autonomous is itself a major mistake in categorizing. The fabricated separation of an integrated set of policies into autonomous parts has two kinds of consequences

6. Peter Linebaugh, *The London Hanged: Crime and Civil Society in the Eighteenth Century* (New York: Cambridge University Press, 1992).

7. Michael Merrill, "History by the Neck," *Nation* 254 (June 22, 1992): 862–64, esp. 863.

that are vital for the survival and the legitimacy of regimes: unpopular actions can be portrayed as deviations rather than the inevitable outcome of the regime's ideology and value system; and effective analysis and alleviation of problems are hindered and become unlikely.

Those results would never appear if news reports and official statements made it clear that seemingly piecemeal governmental actions comprise an indissoluble whole: an integrated system in which the unpopular policies are typically the inevitable outcome.

Consider some of the most common kinds of news that are reported as separate stories in the media, studied as discrete subjects in universities, analyzed by specialists with diverse academic training, and addressed by governments as requiring remedies or solutions that are independent of each other: fiscal policy, monetary policy, crime, military budgets, unemployment, elections, mental illness, racism, sexism, local and national police operations, health policy, educational policy. The close ties among these public issues are apparent to anyone with even a modest understanding of public affairs and social science; but neither the media, nor the government, nor the universities typically present them in a context in which the focus is on the analysis of their connections. Reports and studies concentrate instead on the diverse problems they present.

But it is precisely the links among them that explain their dynamics and provide a basis for dealing with them effectively. Almost always some public policies cause problems in other areas; and a political emphasis on certain issues that generate strong emotions frequently induces officials and the public to ignore other issues that have a greater impact on well-being and that may have given rise to the emotionally charged issues in the first place.

Consider a common and important example. The least seductive concerns for most of the public, and therefore for the media and for public officials as well, are technical economic policies and problems. They are typically hard to understand, and they seem to deal with abstractions, often complicated numbers, rather than

helping or hurting specific groups of people. Their direct and potent ties to a whole host of social problems that do get a great deal of public attention (such as poverty, crime, unemployment, inflation, recession, and the distribution of educational resources and prosperity) are therefore easy to miss or ignore, and news reports typically do miss or ignore them. To try to solve or ameliorate any of these prominent concerns without paying close attention to their sources in fiscal and monetary policy is to ensure that remedies will be superficial or entirely beside the point. An action of the Federal Reserve Board that raises or lowers interest rates or bank discount rates draws yawns from most of the public, but it is likely to affect their well-being in a substantial way. It may induce or aggravate a recession, contributing to poverty, homelessness, the inability of state and local governments to deal with social problems, and all sorts of social tensions, including racism, sexism, and the inclination of people afraid of sinking into poverty to blame those who are even worse off than they are themselves.

Sensitivity training, job training and counseling, welfare for the poor, shelters for the homeless, and similar policies become necessary; but they deal only with symptoms, which are likely to remain serious or grow worse as long as their causes are not addressed.

Other tempting political responses make the problems worse and generate actions that are even more counterproductive. Public chagrin and embarrassment about welfare recipients, the homeless, and those who commit the crimes of the poor (burglary, mugging, etc.) are likely to yield cuts in welfare eligibility and benefits and larger prison populations, all of which make it harder to support families and more likely that crime will increase. Poverty, homelessness, and crime are nonetheless reported, studied, and treated as autonomous social problems or as the fault of their victims. They are rarely linked to their economic or social origins or to the misconceived public policies that aggravate and perpetuate them.

Why are they not usually the fault of their victims, as a great

deal of popular opinion and right-wing rhetoric maintains? It is true enough that not every victim of poverty resorts to crime or becomes homeless or fails to obtain a good education; but it is also certain that a large number of poor people will succumb to these problems as they try to cope with poor schools, housing shortages, serious levels of unemployment, and inability to provide food and clothing for their families. The conservative argument that the poor have themselves to blame for their problems obviously confuses an explanation of why some people manage to avoid those problems with the fact that most cannot possibly do so because the problems are not rooted in individual inadequacies, but rather in social inequalities and social institutions that make life too difficult for many to cope.

Another striking outcome of the practice of treating an integrated set of issues as though they were autonomous is justification of governmental failure to solve or ameliorate them: partly because blame is assigned to their victims, partly because they appear to be unsolvable by any measures that are feasible for governments to undertake.

CATEGORIZATION AND IDEOLOGY

The terms used most frequently in political discourse are potent ideological weapons because they are accepted and categorized as factual or descriptive. The terms *leader, government, official, regulation, welfare, defense, election,* and so on reassure the public that its interests are being protected: that public officials who understand difficult issues will handle them competently and with integrity and will reflect the wishes and needs of the population as a whole. These terms accordingly help induce support for the public policies that regimes pursue and acceptance of the sacrifices that they entail, even while media accounts and political science textbooks and lectures deploy them as objective descriptive tools.

Each of them is a contestable metaphor, not a factual description. Candidates for high public office are seldom "leaders" and are unlikely to achieve or keep their positions if they do not conform to established policies and ideology more often than they

innovate.[8] "Defense" always involves substantial preparations for offensive military actions, often fails to protect home populations, and even more often imposes severe economic burdens on those populations. "Regulation" has served the interests of the economically powerful groups ostensibly being regulated more than it has served the interests of the general public or of politically weak groups. This pattern of reassuring tropes that are belied by the actual functioning of the institution in question applies to every such term that regimes socialize people to accept as simply descriptive. These terms serve as key bulwarks of the dominant ideology by depicting threatening actions as reassuring, not by describing an objective reality.

Misleading beliefs about what causes what are all the more powerful in politics because we typically see our opinions and those of other people as consistent, firmly based in moral commitments and an unchanging ego. We do not easily recognize how volatile, easy, and deceptive the process of constructing opinion typically is.

The assumption that opinions are stable is itself based on a category mistake, of course—that of opinions about political issues as an individual rather than a social phenomenon. If opinions were indeed rooted in each individual person's "character" and reason, they would consistently reflect that person's moral qualities and capacity for logic. But opinions always involve social role-taking, social influences, and social pressures, making them both volatile and readily rationalized as they change. Categorization is fundamental to their creation and re-creation and to their rationalization as well.

The misleading empirical and moral neatness and stability that conventional and dominant categories evoke means that most of the population of the world underestimates its capacity to change social and political institutions because those institutions seem to be natural and justified regardless of what outcomes they produce, even if those outcomes are failures or disasters.

8. Cf. Edelman, *Constructing the Political Spectacle*, pp. 51–53.

The Reagan administration can be admired as an instructive lesson in the remarkable possibilities for rationalizing failures, though that is not how it is usually categorized. These were the years of a deliberately created severe recession in 1981 and 1982, of growing poverty and homelessness, of a declining standard of living for the middle class, of continuing rebuffs to women and minorities, of the Iran-Contra scandal and the savings-and-loan scandal (the latter two unprecedented in American history for the extent of deceit and corruption they revealed and the costs they imposed upon taxpayers), and of the placing of financial burdens on the cities and states with which these units of government cannot cope. Yet Reagan and his administration remained extremely popular, his designated heir was elected by a landslide to succeed him, and there is continuing esteem for Reagan and his advisers. Clearly, political success and failure depend on constructed categories, not on the benefits and costs that political actions generate.

Because conventional categories are hard to dislodge, especially when they are parts of an integrated, mutually reinforcing network, there are occasional efforts by those who suffer from them to shock opinion into reconsidering them. A dramatic example of this tactic in recent decades is the "performance art" of women who resort to flamboyant strategies, such as covering their bodies with chocolate, to call attention to the demeaning purport of conventional categorizations of women. Because these classifications maintain women in subordinate and often debased roles, a dramatic focus on their ignominious implications can become a strategy for destabilizing them.[9]

EXPRESSION, IMAGES, AND COMPARTMENTALIZATION

The connections among misleading language, public opinion, and public policy are powerful, though subtle. Language works no magic by itself. It does not *create* errors in belief and in governmental action. But it can play powerfully upon established prejudices, spread biases to a wider population, and make them com-

9. Cf. Danto, *Encounters and Reflections,* p. 148.

pelling elements in formulating public policy. It does so all the more effectively because the role of language as itself a form of political action is not readily recognized.

As noted earlier, it is the *expression* of ideas that makes it possible to hold them, think about them, react to them, and spread them to others. There must be an image, as articulated in art, in words, or in other symbols. The notion that an idea can somehow exist without objectification in an expression of any kind is an illusion, though the expression may take the form of a term or image in one's own mind: i.e., as a contemplated exchange with others.[10]

That ideas exert their influence only when they are objectified in an image or a linguistic term explains a disturbing phenomenon that repeatedly appears in individual thought and in public opinion. People readily express different, even contradictory, beliefs when focusing on different images or linguistic cues. Each image can evoke opinions that are insulated from other opinions. The person who believes nations should not "interfere in other nations' internal affairs" may support a military invasion of a country, as of Panama or Iraq, when the country's leader is depicted as "aggressive," "corrupt," "a madman," or "a Hitler." Images objectify hopes, fears, moral stances, enthusiasms, and revulsions, and so become the focus of attention and the generators of opinions.

For many whites and males, the depiction of the poor, minorities, women, and other disadvantaged groups as responsible for their own problems, as embodying evil or criminal tendencies, or as inherently less competent than the affluent, whites, or males is an effective way of justifying their own successes as deserved, or excusing their failures as the product of misguided policies that unfairly benefit inferior groups. For much of the middle class and even for many liberals, a term like *workfare* or *affirmative action* calls up these emotionally charged ideas and channels them into political action, just as more blatant and crude expressions of racism or sexism ("spic," "sexpot") do so for people whose biases

10. Cf. Mead, *Mind, Self, and Society.*

are more overt and self-conscious. The prejudices and the language evoke and reinvigorate each other.

But alternative images and the categories they imply can evoke alternative sentiments and actions in the same person, regardless of their logical incompatibility. The advocate of "freedom of expression" may also support the censorship of works of art and literature when they are classified as "obscene" or "subversive." The person who blames the poor for their own plight can also be responsive to an evocation of the unequal chances for success faced by those born into poverty and those born into affluence.

That kind of compartmentalization and contradiction is most likely to occur respecting issues that are reported in the media but are remote from a person's daily life. In that situation, terms and images encourage the projection into an issue of the fears, hopes, frustrations, and ambitions associated with the image in question; but such ready compartmentalization and inconsistency are less likely respecting problems and challenges encountered in everyday life, because immediate experience then helps correct delusions and misconceptions. Satisfaction or dissatisfaction with one's job is likely to hinge more on everyday experiences than on the words and images in brochures published by the National Association of Manufacturers or in Marxist writings.

Still, most opinions about public affairs do stem from reports about matters remote from everyday experience: wars in distant places; a civil rights bill that chiefly affects minorities of which one is not a member; actions of a Federal Reserve Board whose functions one understands only dimly; and so on. In these common situations interpretations are easily influenced, for there is little available evidence to counter whatever claims are advanced.

Those who do advance them, moreover, are likely to win a wide hearing by linking their claims to a relatively small set of widely taught and deeply held assumptions that also rest upon neat categories: the need to support a leader in time of crisis, for example; the need to resist or attack a threatening villain; a promise that a feared or hated current condition (crime, poverty, immorality) will be eliminated if a particular policy is pursued.

When they are effective as propaganda, the stock situations, characters, and scenarios are vivid and morally explicit. There is no question about who is a hero and who is a villain, which actions are ethical and which are sinister. The reduction of multiple, competing claims to moral justification and the reduction of rational action to neat contrasts between evil and virtue, competence and error, evoke a herd spirit. The focus is strongly on subjects who make choices—choices that are good or bad, successful or incompetent. Clear cues generate widely supported admiration, anger, or the impulse to attack people who are depicted as alien or suspect.

These invented political worlds have no room for people whose choices are dictated, encouraged, or limited by the situations in which they find themselves; such worlds are therefore not morally ambiguous, as the world of our everyday lives typically is. In the world of stock categories neither poverty nor cutthroat business rivalry provides an inducement or a need to break laws; bureaucratic settings and pressures do not tempt or coerce staff members to grow insensitive to clients or induce clients to evade rules; and leaders innovate rather than follow constructed opinion.

In everyday life there are constant responses to morally unclear situations, but they are not the stuff from which political appeals and successes grow because they blur both moralistic claims and rational strategies. They require individual weighing of fuzzy and often unappealing alternatives, so that those who are caught up in them must look at their contemplated actions from the perspectives of many people important to them. Social solidarity and pressures to conform to the dominant view cannot be the key influences. In place of enthusiasm and a sense of solidarity with the herd there is likely to be ambivalence.

Although the imaginary worlds we create do not *describe* the complicated, often confusing and murky world in which we live, they do powerfully *rationalize* policy outcomes in that world, helping people to adjust to their social situations and accept them, whether they are affluent and powerful or poor and powerless.

As already noted, the most common classification mistakes and

the most pervasive errors in attributing blame for problems and policy failures and praise for successes make life worse for the disadvantaged and benefit those who already enjoy the most of what there is to get. It is not hard to understand why political language reflects and reinforces that kind of inherent bias. We are socialized into the dominant ideology from infancy on: trained in subtle and explicit ways to admire the successful and become suspicious of the abilities and integrity of the disadvantaged, even if we are disadvantaged ourselves; and works of art accomplish a great deal of the training. More important, the classifications we learn use political issues to express a compelling though usually subliminal narrative about who is meritorious and who undeserving. What seems to be an objective term for describing people or actions is an ideological weapon.

Such dubious categories also construct and maintain animosities because they depict the differences between good and evil, threat and alliance, as clear-cut. A full picture of the reasons for developments in the light of their historical backgrounds, the influence of settings and social structures in constructing people, and the recognition of hostile acts as by-products of a world we never made would, of course, help us see them as far from clear-cut. In this sense news reports can be understood as a never-ending supply of fuel for often misleading narratives, prejudices, loyalties, beliefs, and animosities, which in their turn generate still more news that exacerbates established biases and conflicts. The result is a vicious circle of news, actions, and beliefs that often escalates into a spiral and makes escape into a more hopeful pattern unlikely.

Categorization is fundamental to expression, meaning, and ideology, and therefore to political success and failure, which depend on constructed categories rather than on the benefits and costs that political actions generate; for the categories shape our definitions of benefits and costs. And they are always contestable.

That depressing conclusion has not been evident throughout American history or world history. It is valid at the end of the twentieth century for the paradoxical reason that the mass media

can now reach virtually the entire population for the first time in human history; and while in theory the media can inform and educate, regimes and interest groups have learned that in practice they can use the media to place mass audiences in invented worlds that justify the outcomes of any policies at all.

A Reassessment of Influence
on Public Policy

The earlier chapters of this book have considered the influence of art on assumptions respecting such cardinal political issues as the purposes of the state; inequalities in social status and rewards; the maintenance of social order; the relative importance of social institutions and of individual subjects in affecting well-being; the significance, or lack of it, of politics in individual lives and welfare; threats to personal and national security; assessments of the past; prospects for the future; and other matters that underlie specific governmental actions.

The common assumption, into which the state and society repeatedly socialize both children and adults, is that, in a democracy, elections and the presentation of demands to public officials are the key influences on governmental actions and policies. But there is less and less ground for confidence that those processes do win significant power for most of the general public. If they do not, that disturbing development makes it all the more important to recognize the kinds of influence art exerts in politics and to place that influence in perspective. It calls as well for a reexamination of how power is wielded in the contemporary state. This chapter examines the reasons for the conclusion that elections and lobbying are not reliable avenues of popular control; it also calls attention to the role of art in shaping elections and lobbying and their consequences for governmental policy.

GROUNDS FOR CONCERN ABOUT PUBLIC INFLUENCE

Children learn that in a democracy, the people rule. That reassuring belief is reinforced in adults as they are repeatedly told that voting in elections and presenting their policy demands and preferences to high officials are the means through which the people

exert their sovereignty. Stories about the advancement of democracy in the past, about the importance of popular votes, and about the heroic roles of historic figures in furthering the interests of the people constitute a key bulwark of the prestige of elections and of faith in a wholesome link between the public and officials. Trust in these institutions as pillars of democracy lends legitimacy to regimes and almost always maintains public acquiescence and order, even when there is substantial dissatisfaction with actual policies. In contemporary democracies this faith has replaced earlier trust in the divine right of kings and in hierarchical superiors as insurance against rebellion and social turmoil; in those eras, art in diverse genres similarly played a dominant role in maintaining the legitimacy of regimes.

Although elections and lobbying are avenues of influence, they are not guarantors of democracy, and in the late twentieth century they have sometimes become threats to democracy, for reasons to be examined shortly. Beliefs about public participation that encourage quiescence but are often invalid are hardly reassuring. They need to be replaced with a searching examination of types of influence and what each accomplishes. That exercise involves close attention to those roles of art and cultural institutions in influencing public policy that have already been considered, and also to their roles in rationalizing the place of elections in the polity.

The channels of influence in which people are socialized to have the strongest confidence do bestow authority to shape policy; but they bring influence largely to the elite minorities that already enjoy the greatest control over government, while the benefits the general public derives from them are restricted and short-lived. In no significant sense do they confer on ordinary citizens influence over the governmental decisions that most intimately and strongly affect their well-being, such as standards of living, the waging of war, and most of the liberties and inequalities that shape the gratifications and the afflictions of daily life. Elections as the core symbol of democracy cloud perception of their limitations and often of their specific consequences as well.

ELECTIONS

Consider the distinction between the discernible functions of elections and the conventional illusions about them. In the age of television, nomination for high public office hinges on substantial financial resources, so that the range of choice presented to the voters is severely but not randomly limited and is heavily skewed against those who are already disadvantaged, notably the poor, minorities, and women. Serious and enlightening discussion of issues has largely vanished from election campaigns, the victim of the candidates' and the media's focus on brevity, physical appearance and demeanor, pseudo-events that are created only to be reported, sound bites that appeal to biases or create them, and an emphasis on who is winning in the polls rather than what the aspirants for office represent. All of these are forms of spectacle, art, and artifice in political institutions of the kinds considered in chapter 6. Even when issues are discussed, they are increasingly treated as opportunities for creating facile promises and threats that polls suggest will have wide resonance. Elections are rarely occasions for probing analysis and argument regarding historical, social, and economic problems. Candidates typically fear that such discussion will bore audiences.[1]

Nor are election outcomes often significant influences on subsequent governmental policies. Election "mandates" are ambiguous if they exist at all; different groups and officials read them in diverse ways that serve their respective interests and ideologies.[2] Even more important, legislative, administrative, and judicial actions are responsive to established inequalities in the resources of various groups trying to influence them and to developments that were not foreseen during electoral campaigns and usually could not have been, rather than to votes with ambiguous and controversial meanings.

The conclusion is apparent that elections are chiefly significant

1. Jamieson, *Dirty Politics*.
2. Hershey, "Constructing Explanations of Election Results."

as *legitimators* of the actions of public officials and as a way for citizens to express their enthusiasm—or, more often, their anger and distaste—for some of the options presented to them. Only in a minor way do elections shape future actions. They create the impression that elected officials and their appointed subordinates are guided and constrained by the power of the electorate. In doing so they substantially augment the powers of incumbent officials, even while those officials have to respond in their everyday actions to interest groups that are grossly unequal in their abilities to wield sanctions. For citizens who lack real power, then, elections are an especially potent form of symbolic reassurance; they justify governmental actions more effectively than they generate them.

Indeed, elections increasingly *weaken* the influence of most of the public, for they encourage quiescence, or acquiescence, in the face of policies that damage the interests of large segments of the population while augmenting the influence of the few who already control substantial resources.

Regimes are able to retain the support of electoral majorities while pursuing policies that those voters dislike. Opinion polls showed that majorities opposed many of the key policies of the Reagan-Bush administration, including massive tax breaks for the rich, transfers of wealth from the middle class to the affluent through taxation and spending policies, efforts to cut social security benefits, and military support for the contras in Nicaragua, not to mention unpublicized policies like the exchange of Middle Eastern hostages for armaments and the use of public funds to guarantee profits for savings-and-loan associations regardless of the incompetence with which they awarded large and risky loans to favored clients. But faith in the democratic character of the regime was never significantly shaken, nor, for a period of at least eleven years, was its popularity or its ability to win the elections that were the key buttresses of that faith.

American regimes repeatedly declare that the scheduling of elections is the critical test of democracy in third world countries they support. That assurance is often necessary to counter evidence

that the governments of those countries are repressive, dominated by their armies, tainted by denials of human rights, or able to survive only because of American military aid. In November 1990, the Bush administration hailed a scheduled election in Guatemala as proof that its puppet regime was democratic, even though only right-wing parties were allowed to participate in the election and the army remained the true power in the country, acting independently of elected officials and engaging in widespread torture and killings with impunity.

In an age in which regimes and powerful interest groups can easily reach virtually the entire population through the mass media, then, elections legitimate dubious and unpopular actions so effectively that their frequent, though certainly not their only, consequence is to inhibit or frustrate democratic government.

The American presidential elections of recent decades have epitomized this threat to democracy. More and more blatantly they have exploited anxieties and suppressed or distorted discussions that would enlighten people about the reasons for their discontents. Candidates typically either avoid discussion of the issues that affect well-being, discuss them in ambiguous terms that encourage the public to read their own preferences into the statements, tie them to pervasive racial, gender, class-based, or other biases, or make promises that they abandon if they win the election. They have learned that it is possible to win many elections with sound bites, negative campaigning, the construction of deceptive candidate images, racism, and sexism.

The reasons are clear enough for the discouraging silence in election campaigns about the concerns that determine how well or badly people live. To deal effectively with those problems would require taxation of those who are politically most powerful and who contribute to candidates and to both major parties the enormous sums required to carry on contemporary political campaigns. It would also require policies that would immediately benefit those who are least influential in the political arena. Avoidance of the issues and a focus on rancor toward the poor and minorities bring in contributions when they improve candidates'

standings in the polls. Television news (perhaps the cardinal oxymoron of our time), and newspapers that imitate television graphics and publish short stories that purport to be news, are effective vehicles for that strategy.

The mass media and the strategies of many candidates have largely converted election campaigns into media events, treating them as sporting contests and obscuring the emptiness of the ritual, but relying heavily on art to bring about these results. Because a great deal of the available campaign money comes from corporations whose profits, in turn, stem from government contracts, public subsidies, and fiscal and monetary policies, a vicious circle surfaces. Beneficiaries of public policies use their resources to ensure that the conditions that made them affluent and influential will persist, even while periodic elections sanctify the outcome without examining its causes or consequences. These developments, together with the frequent avoidance by opposition parties of even the modest functions that they exercised in the early twentieth century, contribute to a political scene in which elections increasingly have a changed function: to *avert* public influence in government and deflect policies that seriously address national problems. When many people can vote but lack other resources, elections are bound to reflect and magnify their unequal status rather than temper the inequalities.

In this light the disaffection from the voting booth of much of the American electorate can be recognized as an intelligent response rather than a failure to accept civic responsibility. About half the eligible voters now fail to participate in most presidential elections, and much larger fractions fail to vote in less publicized elections at all levels of government.

Because contemporary elections often reinforce and justify established inequalities, it is hardly surprising that elites and beneficiaries of existing institutions direct a great deal of effort at persuading people to vote, even as a great many refuse to do so. Participation in elections may not influence policy, but it does involve people in a potent ritual and so helps inoculate the participants against cynicism or profound skepticism about the extant

social system. But there will be even more ground for pessimism if elections continue to be accepted uncritically as instruments that magically empower the masses and create democracy.

PRESSURE ON GOVERNMENTAL BODIES

The other activities that instill confidence that government is sensitive to the people's will—lobbying and other forms of persuasion of officials—are even more clearly responsive to established power and resources than voting, and even more conspicuously unresponsive to citizens who lack the means to impose sanctions. Only well-heeled groups can hire and maintain effective lobbyists, often former members of the legislative body or the administrative agency; can distribute literature to constituents who might bring pressure on public officials; and can make substantial contributions to election campaigns, an especially potent source of influence as campaign costs escalate.

More important in the long run, resources in the forms of money, status, knowledge of where to exert pressure most effectively (a form of intelligence which is increasingly bought at high prices), and support from the mass media furnish a decisive advantage in dealings with all the organs of government, legislative, executive, administrative, and judicial. These resources convey a respectability and credibility that groups who lack them cannot command.

Political analysts have long recognized that substantial numbers in support of a cause are irrelevant or actually a detriment to the exercise of influence, compared to the advantages of organization and the ability to deploy resources and sanctions.[3] Every citizen enjoys the right to lobby and petition for redress of grievances; but that right means substantial influence for a relatively small set of groups controlling abundant assets and the means to discipline officials who displease them, while it remains a hollow formality,

3. Cf. Arthur F. Bentley, *The Process of Government* (Cambridge: Harvard University Press, 1908); Mancur Olson, *The Logic of Collective Action* (Cambridge: Harvard University Press, 1965).

though often a reassuring one, for most of the population, and especially for those who suffer from low status, like blacks and Hispanics, and those who are unable to organize effectively in spite of large numbers, like consumers and women.

In recent years radio and television talk shows in which members of the audience can interact with a "host" or with public officials have become popular. In some measure these programs provide a forum for the expression of public sentiment; but, like the other institutions discussed, they often work against democratic change, and the most popular ones exert influence toward rolling back rights and leverage for unpopular minorities, and often even for majorities that are unpopular with smaller groups with strong opinions. Possibly because the callers are anonymous, there is disproportionate expression of racist and sexist views, and of denunciations of the poor and the social programs meant to help them. The net effect of these interactive programs has been to buttress conservative public policies. Talk shows are an especially prominent form of kitsch in the late twentieth century.

Lobbying cannot be understood as the mechanical exertion of pressure on officials. Whether the pressure is noticed and how much attention it evokes depend, rather, upon officials' ideologies, their definitions of reality, and what they understand their constituents' definitions of reality to be. Efforts at persuasion of public officials are ineffectual when the officials assume that the petitioners lack wider support. Assumptions about the degree of such popular support in turn hinge largely on ideology, and lobbying of public officials does not shape citizens' ideologies.

Basic beliefs stem, rather, from signals about the nature of the social world that are absorbed from the symbols to which people are exposed, including those found in works of art, in cultural artifacts, and in looking at the world from the perspectives of other people who are important to the individual. Parents, teachers, and companions are doubtless especially influential in such role taking. The consequences of lobbying, then, depend on more fundamental social transactions, just as the effects of voting do.

DISRUPTION OF SOCIAL ROUTINES

Other modes of attempted influence on public policy through direct action are less conventional and sometimes illegal, but have always been common nonetheless. These include bribery and other forms of corruption, civil disobedience, rioting, and rebellion. Resort to any of these forms of political action self-evidently signals skepticism regarding the effectiveness or fairness of the conventional modes of influence as well as important assumptions about the meanings of governmental actions.

Corruption indubitably does influence governmental actions; but when it occurs on a sufficient scale to make a major difference in policy directions, it involves large amounts of money or other resources and so represents a benefit only to those who command such resources. The Iran-Contra scandal of the Reagan-Bush years illustrates the point, as do many instances of the expenditure of substantial amounts of money on election campaigns with the intention of winning the goodwill of officials in behalf of business interests or ideological causes.

There is also a great deal of petty corruption, such as the bribery of building inspectors, factory inspectors, low-level judges, police, and other officials who can grant small favors or withhold penalties. In many locales these activities are institutionalized, and they typically serve the interests of people of modest means. In a pathbreaking book James Scott has shown that petty corruption is a democratizing institution in third world countries in the sense that it is often the only avenue through which the poor and the petit bourgeois can hope to influence governmental actions that are necessary for their survival.[4]

In somewhat the same way, residents of American cities sometimes learn that small-scale bribery may be the only practical way expeditiously to obtain a permit to make needed alterations on a place of business, assure police protection for the business, secure

4. James C. Scott, *Comparative Political Corruption* (Englewood Cliffs: Prentice-Hall, 1972).

immunity from punitive enforcement of health and safety ordi-
nances, or get a job with the city or the school district. This mode
of influence for the relatively powerless may well be more demo-
cratic and even more efficient in the long run than reliance on
bureaucratic tests that inevitably favor the affluent and so dis-
criminate on the basis of class, race, and ethnicity. Though these
forms of corruption help powerless individuals with secondary
problems, they do not shape major policy directions.

RIOTS AND REBELLIONS

Whatever other functions they serve, riots and rebellions are sig-
nals that existing institutions are violating beliefs about fairness.
If it is only the active rioters and rebels who share those beliefs,
not most of the society, then the rebellion is not supported and
provokes backlash rather than influence. It is beliefs about justice,
fairness, rights, and oppression that are critical, and these reflect
the cultural and economic milieu of the time (often differentiated,
of course, by class, race, age, or other categories), as epitomized
in literature, art, and living conditions. To attribute influence to
the rioting itself, as if it sprang spontaneously from the minds of
its active participants, is to short-circuit analysis and distort the
key issues and their links to one another.

That the direct efforts to influence governments and their policy
directions considered so far are usually accepted as the significant
ones offers an important example of the role of categories and
category mistakes in shaping thought and behavior about politics.
Elections, lobbying, and unconventional direct actions are cate-
gorized as the forms of citizen behavior that carry clout; while art,
science, and social inequalities are classified either as apolitical or
as exerting political influence only indirectly, through the avenues
considered earlier. An examination of those assumptions is now
in order.

INEQUALITIES IN RESOURCES AND STATUS

Command of large resources brings disproportionate influence
and in some measure justifies the inequality through works of art.

As noted earlier, election outcomes and lobbying efforts are themselves highly susceptible to influence from those who can bring to bear substantial wealth, knowledge of where to apply pressure, and high status. That bias in the political system continues to function regardless of issues, elections, or day-to-day maneuvering for advantage.

When inequalities grow large, the political system expands them still more through such measures as tax advantages for the wealthy; governmental subsidies of many different kinds for large business enterprises, including protection from competition; and actions that weaken the lower middle class and the poor so as to lower wages, produce a docile and frightened labor force, and eliminate effective opposition to other policies that widen inequalities. All these sources of inequality become politically possible in part because works of art are available to portray power and powerlessness as necessary, inevitable, or fair.

Once such use of government to exacerbate social discrepancies is well enough established, it becomes impossible to reverse the trend. The United States has almost certainly passed that point of no return. Inequalities are substantial, and they are institutionalized in arrangements for access to such key governmental agencies as the courts, the Federal Reserve Board, the National Labor Relations Board, the Office of Management and Budget, the Department of Defense, the FBI, the CIA, and Congress.

In legislative bodies effective access depends on campaign contributions, networks linking legislators with industries and other affluent constituencies they can help or hurt, and the ideologies of those who hold key legislative offices and committee posts. It expresses itself partly in legislation that directly benefits those constituencies, such as the statutes providing for subsidies and protective tariffs.

More often, unequal access and unequal benefits take the form of ambiguously stated objectives of laws that enable administrative agencies dominated by the powerful constituencies to help the latter through implementing regulations and decisions. Appointments to the more influential governmental organizations guar-

antee domination by elite groups, either by statute or by practice. The legislation establishing the Federal Reserve Board requires that most appointees to the Board be bankers. Strong interest groups typically exercise de facto veto power over appointments to such other regulatory agencies as the Federal Communications Commission and the Securities and Exchange Commission. Law firms specializing in particular areas of public policy have become an especially powerful instrument for the organized groups that benefit from public policy. The substantial costs of effective presentation of cases and of highly specialized attorneys accordingly provide still another decisive advantage to affluent organizations. And the unequal influences that shape administrative decisions apply to the courts as well.

When administrative agencies do occasionally help politically powerless groups through implementing rules, the courts often gut or weaken them. Conservative administrations have also used executive orders for that purpose. This system both allows some leeway for administrative agencies to respond reassuringly to large but weak constituencies *and* guarantees that the response will be slight, temporary, or ineffective when more powerful interests resist it.[5]

Unequal resources similarly play their part throughout the society, perpetuating the inequalities that are already established. The effect is especially telling in education, making it difficult and usually impossible for the poor to overcome their disadvantages and achieve the privileges and influence that the more prosperous and the better educated take for granted.

The advantages that flow to elites from their command of a disproportionate share of economic and social resources are therefore related in several ways to the influences that flow from works of art. Art sometimes plays a decisive role in disseminating the conviction that merit is unequally distributed and that elites deserve their advantages as a result of superior virtue, larger contributions to society, divine grace, or a sacred mission. The Bible and

5. Many examples are discussed in my book *The Symbolic Uses of Politics*.

other writings sometimes justify inequalities in material resources, or devalue their importance, by convincing many that material goods are trivial in the larger scheme of things compared to spiritual salvation. Novels, biographies, and portraits may exalt the personal characteristics that help produce inequalities: strength, shrewdness, or even trickery and skill in exploiting others. Or they may denigrate these talents. Even economic analyses, such as those of Adam Smith and other works that echo Smith's classical depiction of the economic system, influence thought and social action, both by their technical economic accounts and by the epic and dramatic conceptions they bring to political spectators as well as economists. The same observation manifestly applies to a great many scientific writings. Science and art are not as distinct as their usual connotations suggest; their constructed separation is itself a promotion of the interests that benefit from a technocratic ideology.

In any case the impacts on lives and well-being of the various forms of influence discussed here call for reflection, as do their interactions. The final chapter will, I hope, encourage that needed reflection.

Some Concluding Reflections

Works of art are not customarily regarded as avenues of political influence in the sense that election campaigns and lobbying efforts are. But at the close of the twentieth century, art may well be a more fundamental—if less specific—base for political power and for the marshaling of public sentiment about governmental policies than the institutions that are taken for granted as serving those purposes.

Art promotes diverse political interests. Those groups that deploy the largest social and economic resources are usually in a strategic position to utilize art to serve their own purposes as well. Perhaps the most blatant, if not the most influential, form of this political tactic lies in the exploitation of kitsch to further a dominant ideology, as in socialist realist art, or to promote economic gains, as in advertising graphics. Elites also benefit substantially from many deployments of art as components of governmental processes, as in the common reliance on myth, symbol, and spectacle to legitimate benefits and deprivations that are based on class, race, gender, or hierarchical position. Works of art similarly help exploit elections and lobbying so as to win advantages chiefly for those who already wield the largest social and economic resources.

Although art is no more a bastion of democracy than elections and lobbying are, it does strengthen democracy in some respects. Because it excites minds and feelings as everyday experiences ordinarily do not, it is a provocation, an incentive to mental and emotional alertness. Its creation of new realities means that it can intrude upon passive acceptance of conventional ideas and banal responses to political clichés. For that reason art can help foster a reflective public that is less inclined to think and act in a herd spirit or according to the cues and dictates provided by a privi-

leged oligarchy. The observations in earlier chapters about the influence of art on such crucial political issues as challenges to the pieties, the respective roles of the subject and of social structure, transformations of conceptions, ambiguities in political discourse and actions, the aestheticizing of politics, cautions against illusion, the reconstruction of inconsistent meanings, and other matters are grounds for taking seriously the unsettling consequences for thought and politics of the dissemination of art in society. In some measure, then, art helps create a public more aware of its own interests than it was before and more sensitive as well to the stultifying effects on thought and political action of a great deal of political language. By helping to stir people out of an uncritical acceptance of conventional dogma, art doubtless helps energize democracy in some situations.

That art is always a social product, never an individual fabrication, also means that it can both buttress democratic institutions and serve as a potent weapon for elites. The ideas that issue from works of art reflect group interests, as do the particular channels through which art becomes available to a susceptible public. All the great themes that recur in works of art, albeit with differing treatments and points of view, are also vital motifs in everyday life. They are expressed in art in striking ways, sometimes parochial ones, that continue indefinitely to shape and reflect thought, feelings, and response for some segment of the public, and occasionally for virtually all humanity. That art is a social production does not mean, of course, that it asserts or bolsters a majority view, but rather that it is a key component of the kinds of ongoing argument and controversy that pervade democratic government. In this cardinal sense, then, art is not a retreat or a sanctuary from the social scene but rather a consequence and a generator of that scene.

Much of the argument of the earlier chapters suggests that art offers a menu that enriches the civic choices of citizens and public officials. Yet the influences of works of art are readily masked; they provide ideas and potentialities whose origins may not be recognized, so that political activists are likely to accept such ideas as self-generated and to exploit them in diverse ways.

The reasons for the familiar view that art is largely irrelevant to everyday life and politics deserve scrutiny. Even the conservatives who denounce some art as dangerous to morals limit their criticism to a relatively small set of creations and, like most other people, pay little attention to the close links of art to politics and society discussed in earlier chapters of this book.

The key to this sham separation of art from everyday life probably lies in the strained relations that usually persist between artists on the one hand and, on the other, the politicians and business people who wring the greatest rewards from the social and economic system. The movers and shakers are understandably reluctant to recognize that their ideas and contributions often originate in the products of a class of workers commonly categorized as otherworldly and impractical. Indeed, that contestable categorization is itself a political ploy that helps rationalize the high rewards in resources and power that captains of industry and top government officials reap.

Artists themselves contribute to the opinion that their work is in a different universe from the one other people inhabit. It gives them a special status, and most of the time it helps insulate them from pressures to conform in their work and their lifestyles to conventions they may deplore.

Yet artists pay a high price for their limited measure of autonomy. Except for a small number of celebrities, their incomes are low; the market for their work is unpredictable and often nonexistent; gallery owners, publishers, and booksellers absorb a high proportion of the income from their sales; and only a relatively small proportion of the public recognizes their vital contribution to the good life.

The virtually unanimous adoption in everyday discourse, academic political analysis, and the media of the assumption that people base their political views directly on observation or journalistic reports of "what happened," overlooking the intermediary role of art, brings some unwholesome consequences. It encourages overconfidence about political opinions because they seem to be based directly on observation and fact. It yields a mistaken notion

of how political persuasion and discussion become effective because it neglects the crucial function in political thought of images, narratives, stereotypes, and symbols that derive from works of art. For both these reasons it accentuates political conflict and dogmatic persistence in political beliefs.

An equally important result of the dubious categorizations that tend to look in the wrong places and to the wrong social circles for the sources of political conceptions is that a great deal of political commentary, criticism, and discussion bears only superficially on critical political dynamics and on who gets what through politics. We need a more realistic model of politics and its relation to other aspects of social and individual lives and their histories.

Still, it would be foolish to suggest that knowledge of the crucial role of art in politics will necessarily bring more efficacious tactics to those who exercise it. Precisely because artistic origins and influences are fundamental, they deal in general models and images, their specific applications depend in some measure on social and economic conditions, and they serve diverse, often contradictory, purposes.

Although it is a central theme of this book that art is a major influence on government, the two institutions are bound to remain at odds with each other. Art ideally requires absolute freedom of imagination, thought, and expression, while governments inevitably try to restrict the exercise of these faculties and their consequences; and regimes like to define the restraints as freedom. Even in democratic states claiming to promote the arts, the link is always fragile and the arts are frequently obstructed. But that inevitable tension should not mean that awareness of the connections among art and politics is also obstructed.